Christmas Decorations
from Williamsburg

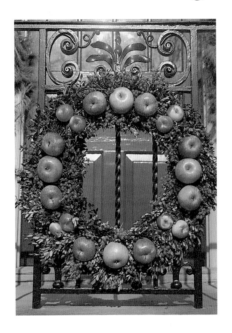

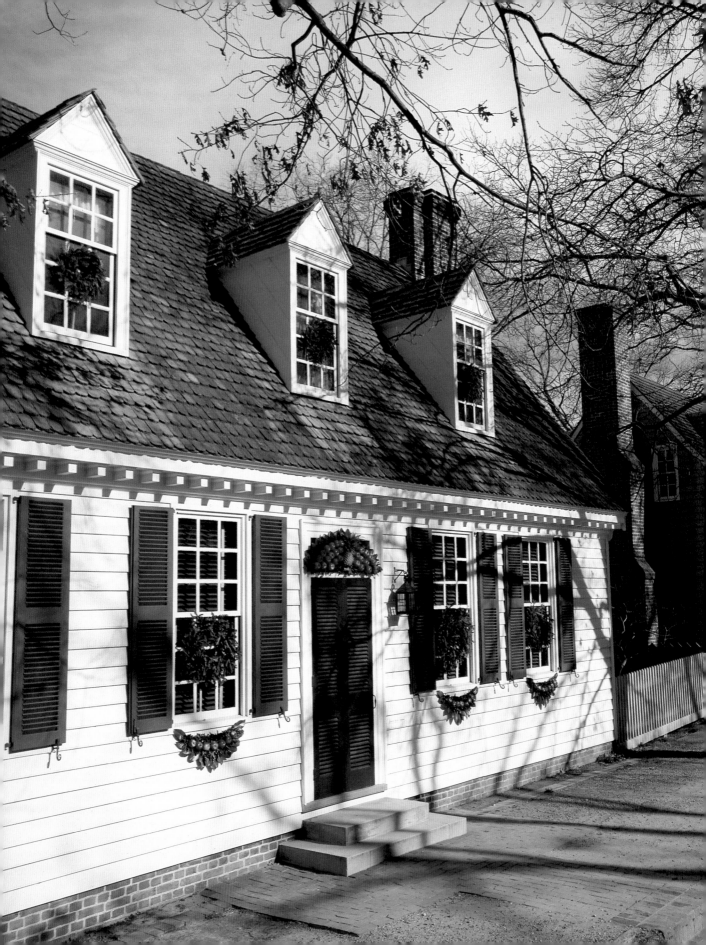

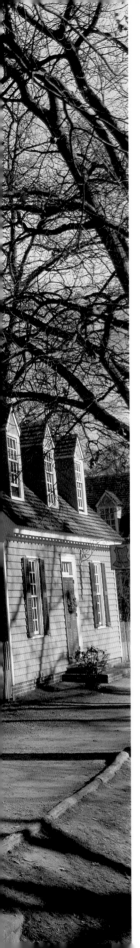

Christmas Decorations from Williamsburg

By
Susan Hight Rountree

Drawings by Elizabeth Hundley Babb

Photography by
David M. Doody and Tom Green

Additional photography by
Frank J. Davis, Robert Llewellyn, and the staff of
the Colonial Williamsburg Foundation

The Colonial Williamsburg Foundation
Williamsburg, Virginia

Library of Congress Cataloging in Publication Data

Rountree, Susan Hight.
Christmas decorations from Williamsburg / by Susan Hight Rountree; drawings by
Elizabeth Hundley Babb; photography by David M. Doody and Tom Green.
 p. cm.
 ISBN: 0–87935–085–7
 1. Christmas decorations. 2. Nature craft. 3. Christmas decorations —
Virginia — Williamsburg. I. Title.
TT900.C4R68 1991
745.594'12—dc20 91–24638
 CIP

This book was designed by Richard Stinely

Printed and bound in Canada

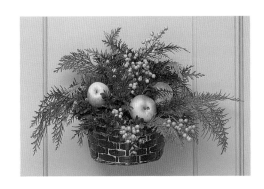

Contents

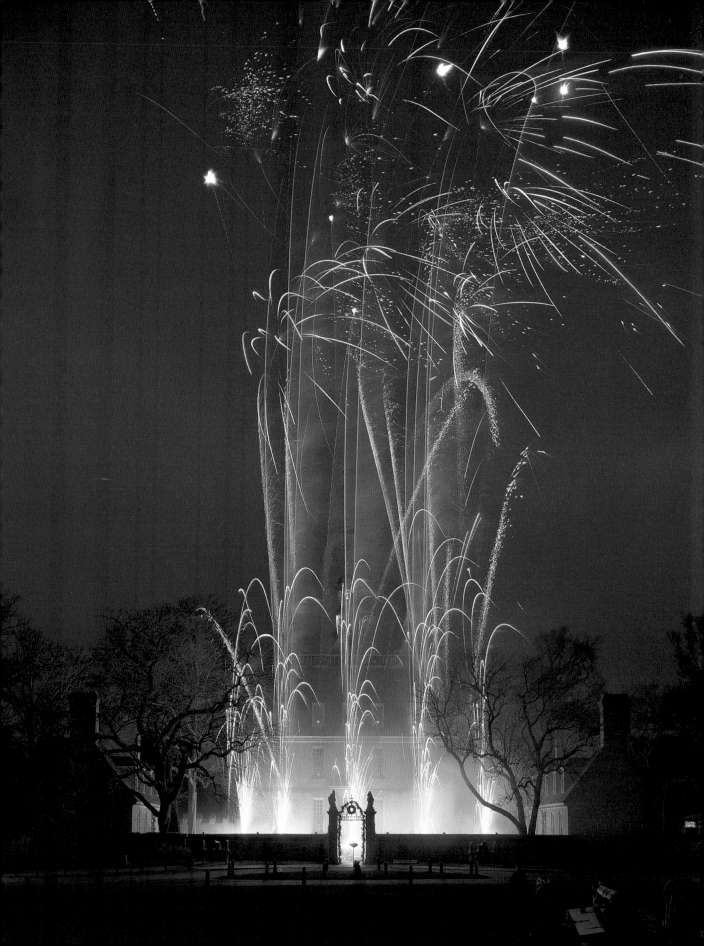

Christmas in Williamsburg

THE SPIRIT OF CHRISTMAS comes early to Colonial Williamsburg, and, on the night of the Grand Illumination, visitors come from far and near to enjoy the festivities and the beautiful decorations.

What fun it is to join the multitude at dusk on Grand Illumination night to hear the cannons boom and watch as the candles are lighted in every window of this venerable town. Glorious fireworks follow, and the streets are alive with carolers, the Fife and Drum Corps, and other instrumental groups. There is music and activity everywhere. Enormous bonfires and cressets light up the streets and the sweet smell of hot, spiced cider mingles with the smoke from the bonfires.

The season extends well beyond the twelve days of Christmas. Nighttimes are given over to assemblies, musical diversions, lanthorn tours, plays, and candlelit evenings at the Governor's Palace and other dwellings and gathering places of the colonial capital.

During the day visitors wander down the streets to view the doorways, browse in the shops, enjoy a hearty meal in a tavern, and visit the historic buildings where they learn about life in eighteenth-century Virginia.

The streets are lined with homes and shops decorated with colorful wreaths and garlands of fresh greens embellished with fruits and berries or dried pods and cones. Inside the colonial houses, taverns, and public buildings and at Bassett Hall, Carter's Grove, Craft House, and the Williamsburg Inn and other lodgings, mantels, stairways, windows, and tables are decorated for the holidays.

The Crown of the Turtle and Baron's feasts and the Groaning Board are among the special meals prepared throughout the season in Colonial Williamsburg's taverns and restaurants.

This sampler of the variety and wealth of decorations that are the hallmark of Christmas in Williamsburg will give you many ideas to use in your own home. We encourage you to experiment with the plant materials, forms, and accessories shown in the following pages and to try a new recipe or two as well.

Opposite: Fireworks exploding over the Governor's Palace joyfully open the Christmas season in Williamsburg.

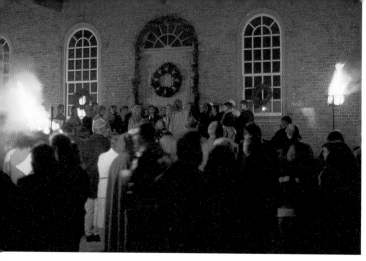

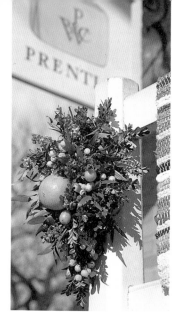

A colorful plaque on the Prentis Store railing reflects the winter's sun. Alexandrian laurel and boxwood form a base for bittersweet, chinaberries, kumquats, and an orange.

Costumed carolers in front of the Courthouse invite one and all to join in song.

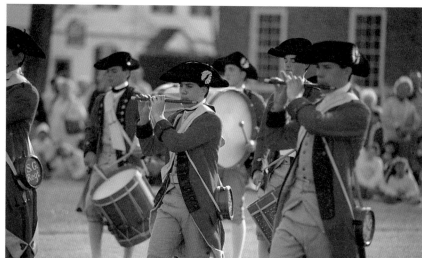

The Alexander Craig Kitchen is bedecked with lemons, oranges, and apples on white pine wreaths.

The Fife and Drum Corps, resplendent in their red uniforms, perform for Christmas visitors.

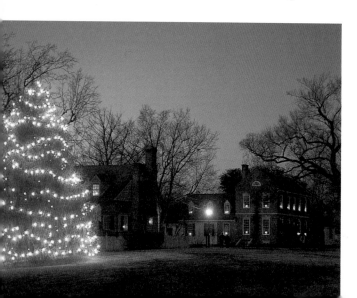

The lights of the community Christmas tree and the nearby buildings beam a welcome to passersby.

A decorated railing near the Golden Ball silversmith shop adds color to a bleak winter's day.

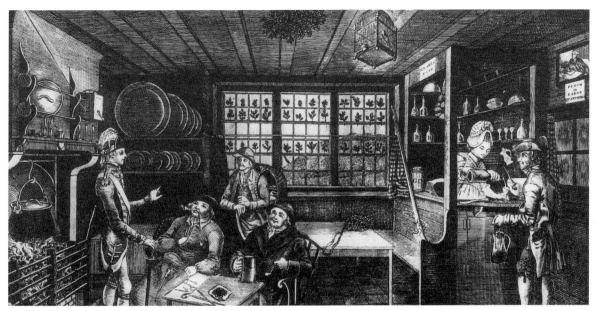

Small sprigs of holly decorate a tavern window in the same tradition seen above in an eighteenth-century print of the interior of an English alehouse.

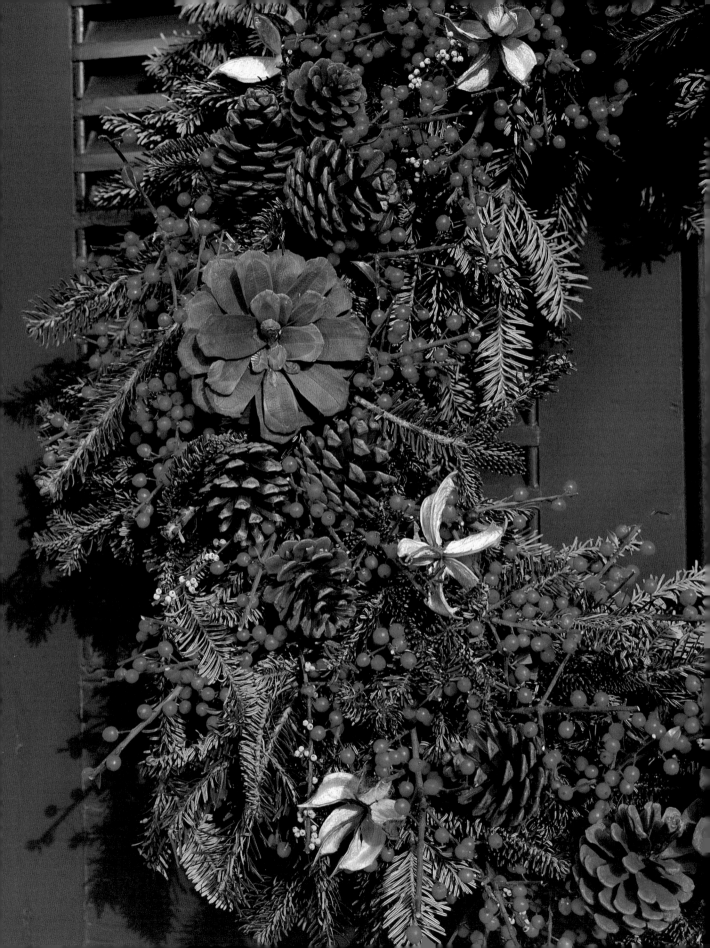

Wreaths and More

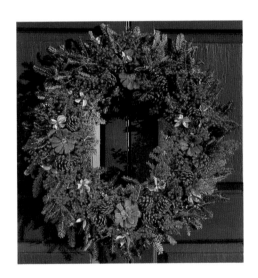

This beautiful balsam wreath successfully
combines empty cotton bolls, Japanese black
pine cones, and loblolly pine cones cut to
resemble flowers. Bayberries and sprigs
of holly berries are added for color.

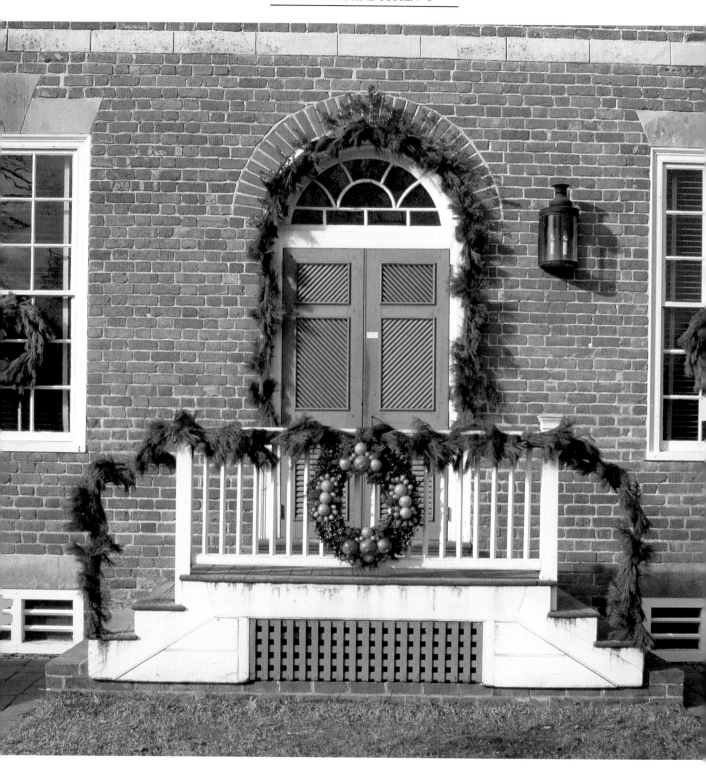

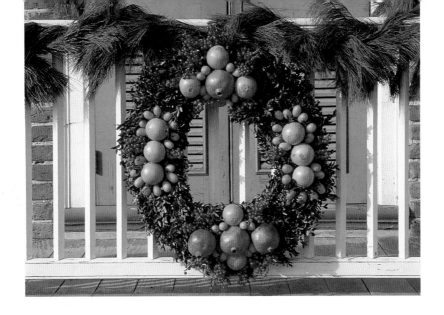

THROUGHOUT Williamsburg's Historic Area both the public buildings and the private residences are delightfully decorated for Christmas with a wide array of wreaths, plaques, overdoor fans, and roping. Even many windows are decorated with wreaths or windowsill arrangements.

We hope that some of the ideas shown in this section will be an inspiration and help you re-create a Williamsburg Christmas for your own home. Perhaps you will select a doorway framed with pine roping with an intricately designed wreath of pomandered apples and oranges on the door and matching colorful accents on the windowsills and door frame. Or you might make window accents and a matching wreath created from a variety of mosses, a pair of symmetrical magnolia-edged apple plaques, or perhaps a classic Williamsburg apple fan and matching window swags to achieve the special Williamsburg look.

Many of our ideas use traditional combinations of plant materials and classic forms, while others combine these materials in less traditional ways. We encourage you to combine fresh and dried materials in new and creative ways. If some of the plant materials used in Williamsburg are unavailable in your area, perhaps the examples shown will suggest other materials that are plentiful where you live. Although most of these decorations are shown on the exteriors of the houses and shops in the Historic Area, many can be used inside as well.

The focal point of the garlanded doorway and railing
of the Roscow Cole House is the spectacular wreath
of oranges, kumquats, pomegranates, and holly
berries on a base of balsam fir.

7

How to Make a Wreath

Wreath of Boxwood or Other Greens Made on a Flat Wire Wreath Frame

Supplies and materials needed: flat 2-wire wreath frame (available in sizes from 10 to 36 inches), #22 gauge spool wire, wire cutters, chenille wire or pipe cleaner, clippers, and 5-inch sprigs of conditioned boxwood or other plant materials (see page 136).

NOTE: Approximately 1 to 1½ bushels of 5-inch sprigs of boxwood are needed to make an 18-inch wreath.

STEP 1. Wrap the end of the spool wire securely around the outside wire of the wreath frame as shown. Leave the wire attached to the spool.

STEP 2. Hold 3 to 6 sprigs of boxwood (depending on fullness) close to the frame and wrap these cut ends tightly with the spool wire.

STEP 3. Wrap the wire around the boxwood and the frame several times so that the boxwood is securely fastened to the frame.

Plain boxwood wreaths hang on ribbons at the Margaret Hunter Shop.

STEP 4. Hold another bunch of boxwood sprigs close to the one you have just attached to the frame and wrap these ends as in Step 2. Place the second bunch of boxwood on the frame, just overlapping the ends. Repeat Step 3 to secure the second bunch to the frame.

Continuing in the same direction, repeat Steps 2 through 4 until you have covered the frame entirely with boxwood. The last bunch

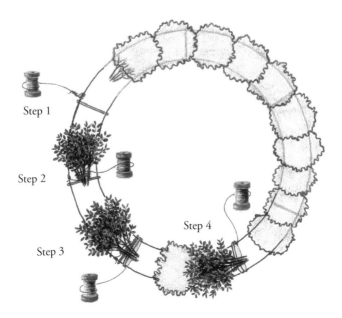

of boxwood should be wired underneath the first bunch you attached by lifting the foliage end and wrapping the last bunch tightly under it. Cut the spool wire and wrap the end securely around the frame. This allows the first bunch of boxwood to cover the wire wrapped ends of the last bunch.

Be sure to keep the size of the clusters and the distance between them uniform. On the back make a hanger with a chenille wire or pipe cleaner and secure it to the wire frame. Trim any uneven areas of the wreath with clippers.

Double-Faced Wreath of Boxwood or Other Greens Made on a Flat Wire Wreath Frame

To make a double-faced wreath, secure the wire and follow Steps 2 and 3 above, first on one side, then turn the wreath over and secure bunches of boxwood on the back. Proceed to Step 4, wiring bunches on both front and back of the wreath form. Continue to cover both sides of the form. Follow the directions to attach the last bunches. Securely wrap a chenille wire or pipe cleaner hanger onto the frame. NOTE: Although these instructions are for a wreath of boxwood, other plant materials can be used if boxwood is not available in your area. Just follow the same steps for conditioning the plant materials and for constructing the wreath. Short-needled pines and firs, hemlock, spruce, Alexandrian laurel, arborvitae, and cedar are but a few of the possibilities.

Pine Cone Wreath

To make a pine cone wreath, use a three-dimensional wire box wreath frame. This frame looks like a flat 2-wire wreath frame that is connected to a slightly larger flat wire wreath frame beneath. White pine cones are recommended for a base because they fit easily in the space between the top and bottom of the frame. Place the cones crosswise on the frame with the stem ends toward the center. Cones soaked briefly in water will close and thus will be easier to insert. Once the basic round shape is made, allow the cones to dry. When the cones dry, they will open and the wreath will be tight and full. You can then wire (see page 29) or hot glue cones, pods, and nuts onto this base. Allow your materials to face in different directions, vary the colors evenly, and use the heaviest materials in the center of the wreath. This will result in a pleasing design.

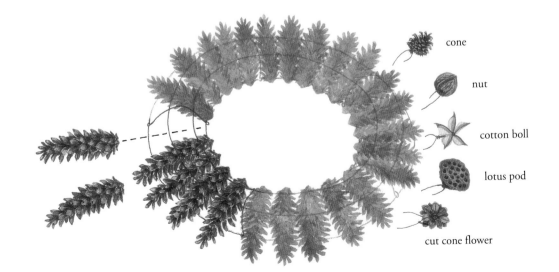

cone

nut

cotton boll

lotus pod

cut cone flower

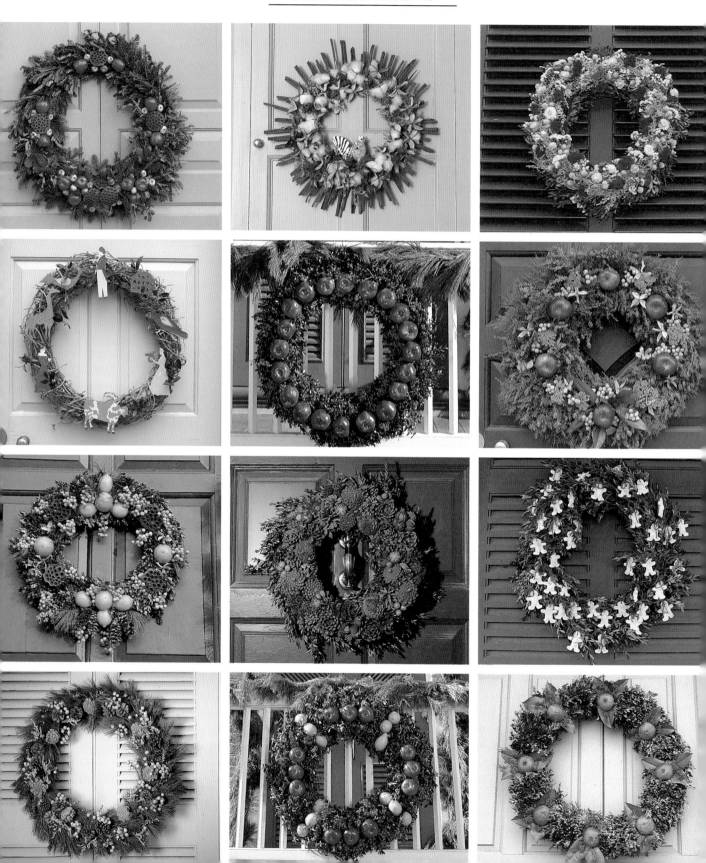

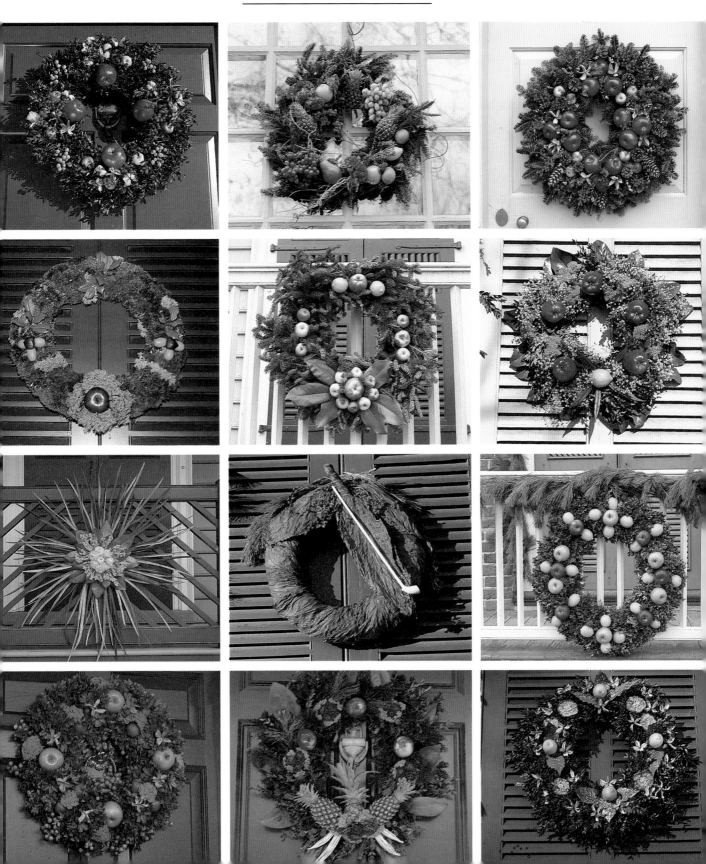

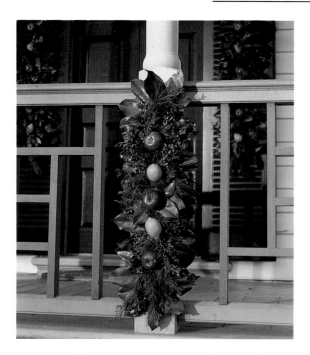

Apples and lemons provide the focal point of this handsome magnolia-edged plaque. Boxwood, white pine, and red cedar serve as the background.

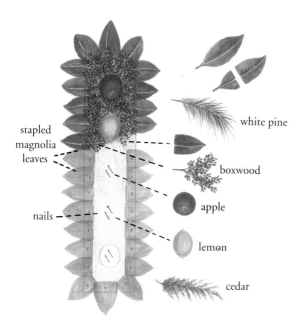

stapled magnolia leaves

nails

white pine

boxwood

apple

lemon

cedar

How to Make a Plaque

Plaque Made on a Plywood Base

Supplies and materials needed: ½-inch thick plywood form, 2½-inch galvanized finishing nails, hammer, clippers, staple gun, hooks, #16 gauge green floral wire, fruit, and conditioned plant materials (see page 136).

The plaque shown here is made on a plywood form that is 3 inches smaller on each side than the finished size of the plaque. The form is painted dark green on the front side and the color of the woodwork on the reverse side if the back will be visible.

To determine the placement of the nails, arrange the fruit on the plywood form according to your design. Mark the location on the form of each piece of fruit. Remove the fruit and drive a nail into the form on either side of each mark. Drive the nails approximately 1 inch apart. The nails should slant upward as shown. These 2 nails will keep your fruit in place.

Trim the stem ends of the magnolia leaves to keep them flat. With the leaves extending 3 inches over the edge of the form, carefully staple the stem ends to the plywood to form an even row of leaves around the edges. Keep the tips of the leaves very even, particularly at the corners. Staple boxwood sprigs over the stem ends of the magnolia leaves.

Cover the remaining area of the form with boxwood sprigs. Impale the fruit on the nails. Tuck in sprigs of white pine and cedar.

Attach a hook at the top and the bottom to ensure that the plaque will hang straight. Use the #16 gauge floral wire to attach the plaque.

Plaque Made in a Plastic Floral Foam Cage

Supplies and materials needed: plastic floral foam cage (available at floral supply outlets), wired and unwired green wooden floral picks, #16 gauge green floral wire, eye hook, clippers, conditioned plant materials (see page 136), fruits, cones, and other plant materials.

This type of plaque is used for plant materials that benefit from being kept moist. These floral foam cages are designed with holes for hanging the finished plaque and are available in various sizes.

Here a natural arrangement of plant materials is shown on this gate, but the plaque could also be hung on a door, wall, or windowsill. The design is established with the white pine, holly, rosemary, and ivy. Briefly soak the foam holder. Cut the stems of the plant materials on a diagonal and insert the materials into the wet floral foam around the outside edge as shown. Work the greens in toward the center.

When the shape is well balanced, impale the fruit on the unwired wooden floral picks (see page 28) and insert the picks into the floral foam. Attach the cones to the wired wooden floral picks (see page 29) and insert the picks into the floral foam. Add the yarrow and pieces of rosemary last to give depth and airiness. It is important to place your plant materials at different heights and facing in different directions so that a graceful effect is achieved. This plaque is very different from the formal, well-balanced, geometric design of the previous decoration.

Make a hanger by attaching the #16 gauge floral wire securely to two holes on the edge of the holder and secure these ends to the surface with an eye hook.

NOTE: A small shallow container (approximately 5 inches square) fitted with floral foam and covered with chicken wire or green floral adhesive tape may be substituted for the cage.

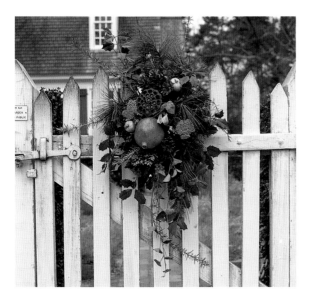

A lovely mixture of greens is the background for this plaque. Holly berries, a pomegranate, lotus pods, yarrow, lady apples, and a variety of cones on the gate to the John Blair herb garden.

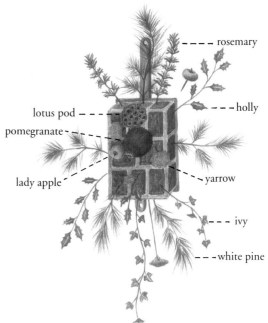

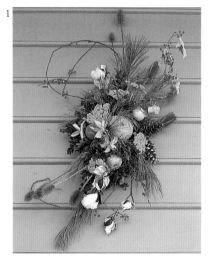

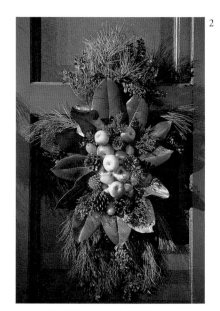

1. The graceful curves of this plaque's design of boxwood and white pine are echoed by the curves of the bittersweet and are accented by the long stems of the yarrow and teasels and the colors of the osage orange, lady apples, cotton bolls, and white pine cones.

2. A T-shaped plaque of white pine and boxwood backs an oval of magnolia leaves decorated with lady apples, kumquats, and scrub pine cones. Sprigs of cedar with lovely blue berries are tucked in.

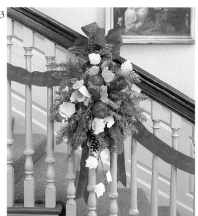

3. A glorious plaque on the ribbon garlanded stairway at Bassett Hall features red apples, tiny red peppers, and white pine cones set against the silvery underside of pressed sprays of white poplar. The plaque is backed with noble fir.

4. An asymmetrical plaque on the railing at the James Anderson House combines red apples, sprigs of holly berries, and small ornamental pineapples complemented by the graceful lines of the hemlock. Magnolia leaves and boxwood are also used.

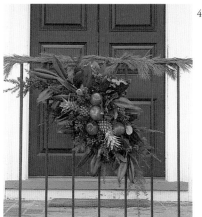

5. A long, bold doorside plaque of lemons, apples, sprays of red nandina berries, and delicate baby's breath is accented with variegated aucuba leaves. The glossy magnolia leaves, boxwood, and white pine provide contrast.

6. This magnolia-edged geometric plaque includes variegated and American hollies, Norway spruce cones, apples, lemons, a pomegranate, lady apples, limes, and boxwood. The variegated holly sprigs add interest and texture.

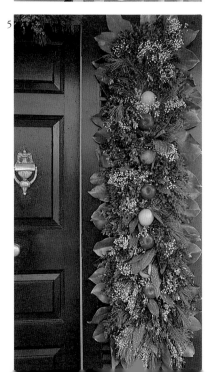

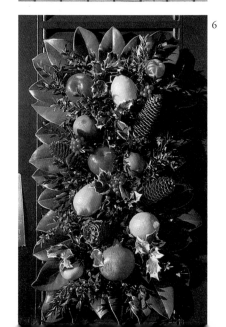

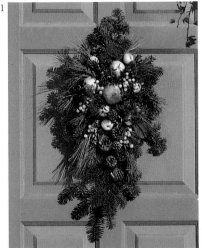

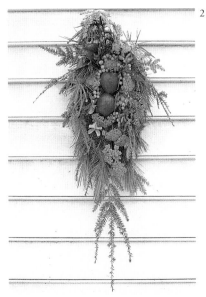

1. A kite-shaped plaque of balsam, white pine sprigs, and boxwood is the foundation for the harmonious color scheme of pomegranate, lady apples, chinaberries, and small scrub pine cones. The brown of the preserved magnolia leaves adds visual interest.

2. At the John Greenhow Store a delicate snow-capped plaque of hemlock with sprays of cones, white pine, and magnolia leaves focuses on shiny red apples surrounded by yarrow, cotton bolls, and chinaberries.

3. Ovals of magnolia leaves frame a pair of plaques on which German statice backs a design of large red delicious apples surrounded by lady apples and lemons.

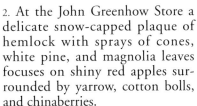
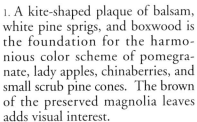

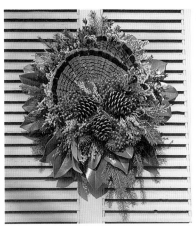

4. A double fan of ruffed grouse feathers is bordered with German statice, nandina berries, loblolly pine cones, magnolia leaves, and boxwood.

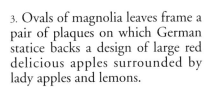

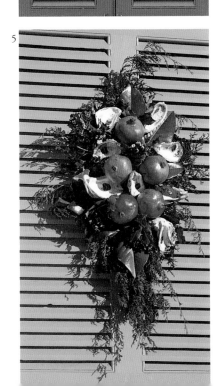

5. Oyster shells are traditionally used at the Nicolson Store at Christmas and are combined with pomegranates, boxwood, American holly, magnolia, and the beautiful gray-blue of the cedar berries.

6. This colorful mixture of pomegranates, lady apples, holly berries, yarrow, and okra pods is placed on magnolia leaves, boxwood, cedar, and rosemary with trails of English ivy, American holly, and white pine. Sprigs of bayberry and white pine cones add depth and interest.

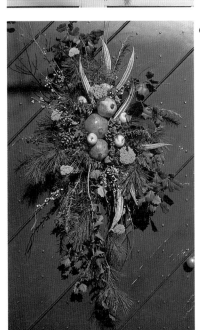

How to Make a Fan

Supplies and materials needed: ½-inch thick plywood form, 2½- and 3-inch galvanized finishing nails, 1¼-inch roofer's nail or other large-headed nail, hammer, #22 gauge green floral wire, clippers, staple gun, wire cutters, large hooks, conditioned plant materials (see page 136), and fruit.

This fan is constructed on a plywood form approximately 3 inches smaller on each side than the total area of the pediment. The form is painted dark green.

Arrange the fruit on the plywood form and mark the location of each piece. Be sure that the design is symmetrical. Remove the fruit and drive the 2½-inch nails into the form at an upward angle. Drive 4 3-inch nails into the center and the roofer's nail above, for the body of the pineapple. Wrap the end of a 12-inch piece of #22 gauge floral wire around the roofer's nail. Drive 3 3-inch nails close together into the top of the form for the pomegranate.

Trim the stem ends of the magnolia leaves to keep them flat. With the leaves extending 3 inches over the edge of the form, carefully staple the stem ends to the plywood to form an even row of leaves around the top edge. Staple more

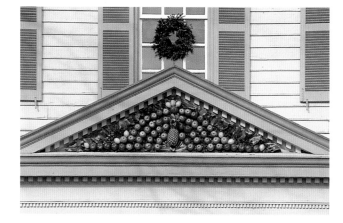

This creative variation of a classic fan enhances the architecture of the Grissell Hay Lodging House. A basic apple fan fills the center, while details such as the row of apples extending outward and the lemon and Granny Smith apples complement the design.

magnolia leaves in the center. Staple boxwood sprigs over the stem ends of the magnolia leaves, the bottom edge of the form, and all other remaining areas so that the surface of the plywood is well covered.

Impale the fruit on the nails in the pattern shown here or use your own design. Impale the pineapple over the magnolia leaves in the center and secure its top with the wire attached to the roofer's nail by wrapping the wire around the base of the foliage.

Attach hooks on the back to attach the fan to the building.

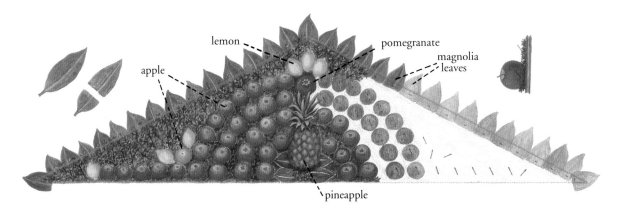

lemon

pomegranate

magnolia leaves

apple

pineapple

A large pineapple on a bed of magnolia leaves dominates the center portion of this beautifully executed classic Williamsburg apple fan above the door of the James Moir House.

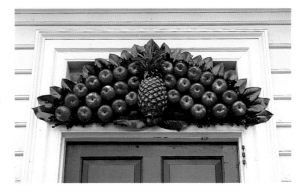

In this fan above a door at the John Blair House, an effective magnolia-edged design with a bed of white pine and holly features a pineapple in the center and rows of green and red apples on either side of a row of loblolly pine cones.

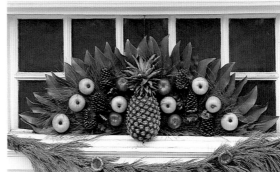

At the Blue Bell the striking pediment fan design includes two sizes of pineapples, limes, red apples, and yarrow within a pointed design made with dried okra pods and intertwined with cranberry chains. Red cockscomb surrounds the central pineapple.

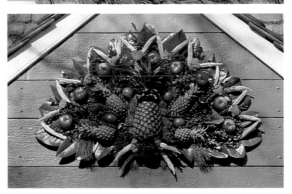

Over the door at Holt's Storehouse, overlapping rows of magnolia leaves and an interesting combination of dried teasels, wheat, cotton bolls, and other dried pods have been inserted in a fan shape around the pineapple.

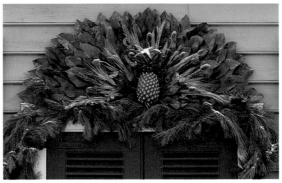

How to Make Roping

Supplies and materials needed: heavy twine or cord, #22 gauge spool wire, wire cutters, clippers, and conditioned plant materials (see page 136).

Leaving a 2-foot length of twine at the beginning, wire a small handful of white pine sprigs approximately 8 inches long together at the stem ends. Hold this bunch on the twine and tightly wrap the spool wire around the white pine and the twine. Do not cut the spool wire.

Continue to attach bunches of greens to the front and back of the cord without cutting the spool wire until you complete the length of roping needed. The last bunch of greens may be wired to the twine in the opposite direction as shown. This will cover the stem ends.

Leave a 2-foot length of twine at the end to secure the ends to your railing or door frame.

The photograph shows the roping in swags and wired to the railing. The apple is wired (see page 28) and secured around the back of the roping. Berries, fruits, and cones may also be used for roping accents (see page 29).

Roping may be made from one or more plant materials such as white pine, boxwood, holly, cedar, or other greens. If roping is thin, it may be doubled. To produce the fullest effect, double the roping and run it in opposite directions. Trim any areas that appear to be too heavy, but be careful not to cut the wire or twine.

Bushy white pine and boxwood roping is caught up on the railing with apple accents.

Plain pine roping may be purchased and other greens, cones, and berries wired onto it by carefully lifting the foliage ends, wiring the additional material to the twine, and then allowing the original foliage to cover the wired ends of the newly added material.

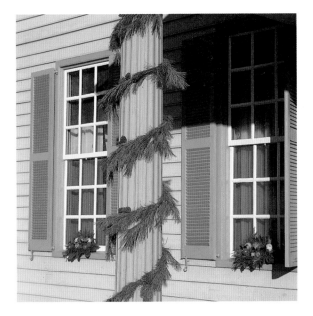

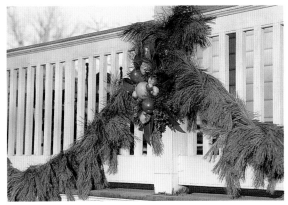

Across the long front porch at Christiana Campbell's Tavern, pine roping is attached to the railing with accents of lemons, apples, oranges, and lady apples on a bed of boxwood and magnolia leaves.

A simple but effective use of roping on the porch columns at the Grissell Hay Lodging House is shown here. Two small cones are wired to each row of roping to create an interesting repetitive design.

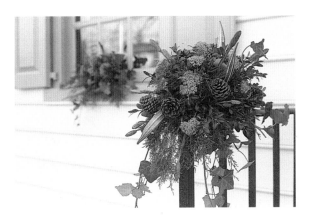

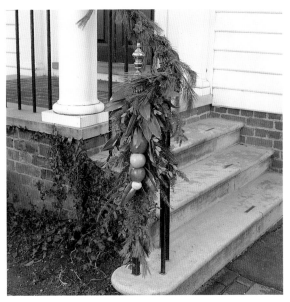

The base of this open and airy cascading accent is a small plastic floral foam cage securely fastened to the railing. The plant materials include yarrow, Japanese iris pods, loblolly pine cones, English ivy, boxwood, okra pods, and cedar.

This finial accent is assembled by wiring several sizes of apples together. The apples are then wired to a short piece of roping, a holly branch, and pieces of boxwood. This whole hanging cluster is wired around the base of the finial. Sprigs of holly and boxwood conceal the wires and stem ends.

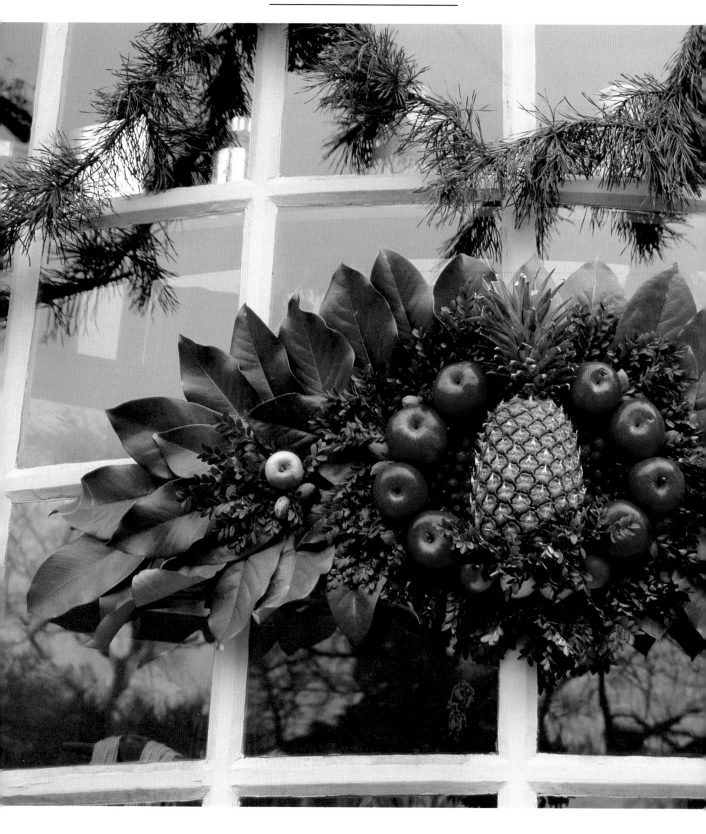

The pineapple, the traditional symbol of hospitality that dates from colonial days, is the focal point of this large and dramatic oval plaque on the curved window at the Sign of the Rhinoceros. Overlapping magnolia leaves form the border. At the center the large pineapple is ringed with red apples, nuts, lady apples, and cranberries on a boxwood bed. Additional accents of lady apples and nuts are added.

How to Make a Window Accent

Supplies and materials needed: plastic floral foam cage (available at floral supply outlets), wired and unwired green wooden floral picks, #16 gauge green floral wire, 1¼-inch roofer's nail or other large-headed nail, clippers, conditioned plant materials (see page 136), cloves, fruits, berries, and other plant materials.

This colorful pomandered window accent is constructed in a plastic floral foam cage. These floral foam cages, which are available in various sizes, are designed with holes in the edge that can be used to wire the arrangement to a large-headed nail in the windowsill. After briefly soaking the foam holder, insert the greens into the wet floral foam at the back, front, and sides to cover the outside of the container as shown. Decorate the fruit with clove designs, impale the fruit on the unwired wooden floral picks (see page 28), and arrange as shown. Attach the lamb's ear, berries, and nuts to the wired floral picks (see page 29) and insert the picks into the floral foam to fill in the

At the John Blair House, a window accent of boldly patterned pomandered apples and oranges is combined with bunches of pepperberries, lamb's ear, bayberries, and buckeyes against a balsam backing.

remaining areas. Use the #16 gauge floral wire and the nail to attach the arrangement to the windowsill.

To pomander fruit, draw a design onto the fruit with a water soluble pen. Use a wooden skewer, ice pick, or other sharp, pointed instrument to puncture your design in the fruit. Wash off the pen marks and insert the cloves.

Window accents may also be made using Styrofoam blocks. The materials are inserted into the Styrofoam block in the same manner as into the floral foam.

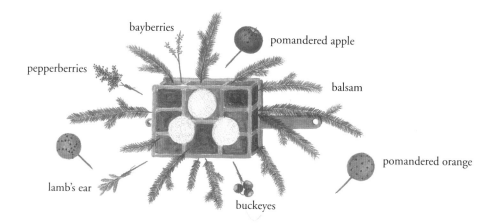

bayberries

pepperberries

pomandered apple

balsam

lamb's ear

buckeyes

pomandered orange

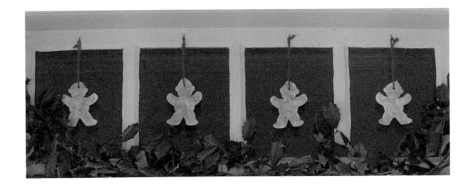

On the Greenhow Tenement, a row of gingerbread boys hangs in this window and repeats the delightful theme of the wreath on their door below.

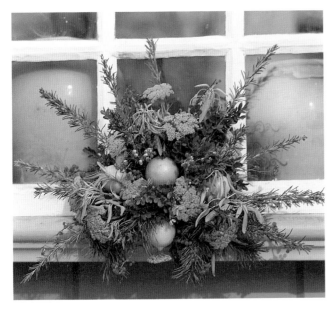

Oranges and yellows dominate this bright arrangement on the windowsill of the Pasteur & Galt Apothecary Shop. Yarrow, lemons, an orange, and sprigs of bittersweet sit in a bed of scrub pine and boxwood. Sage and rosemary add contrast.

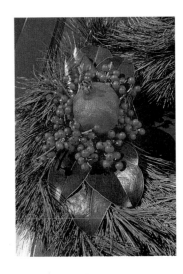

Here are two vivid accents found on roping around windows. Accents can be used to add color to roping, plaques, and other designs. *Right:* The pomegranate is wired onto the roping; bunches of magnolia leaves and sprigs of holly berries with the leaves removed add further interest. *Left:* A different color combination is shown using a lemon, wheat, and chinaberries.

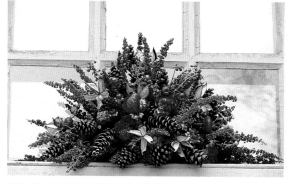

Dried materials arranged over a doorway in a dry floral foam cage include white pine and loblolly pine cones, dock, cotton bolls, bittersweet, red cockscomb, and strawflowers.

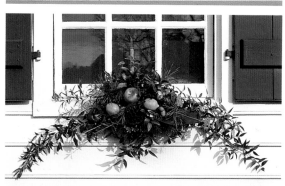

Another overdoor arrangement with a white pine and boxwood background combines apples, yarrow, cones, artemisia, and locust pods as colorful contrasts to the background.

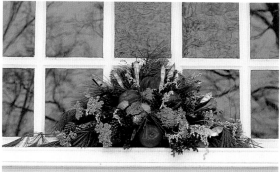

The graceful lines created by the Alexandrian laurel are echoed by the pine and rosemary sprays. Boxwood, magnolia leaves, and holly foliage and berries contrast with the yarrow, lemons, apples, and lady apples as well as the pods and cones.

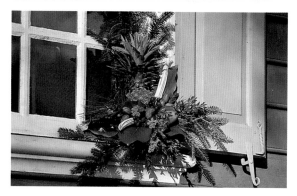

This corner arrangement on a windowsill is dominated by a pineapple on a backing of balsam fir, boxwood, and magnolia leaves. Okra pods, pecans, yarrow, cranberries, and a red delicious apple add interest and color.

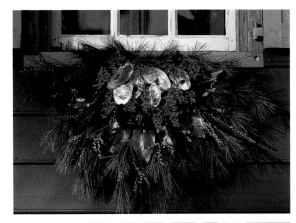

A swag using unusual materials and constructed on a curved wooden form hangs just below the windowsill. Oyster shells dominate this design of nandina berries and bayberries on a base of magnolia leaves, white pine, and boxwood at the Nicolson Store.

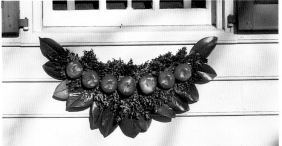

This handsome swag at the James Moir House is made in a similar fashion with a curved row of red apples over boxwood and magnolia leaves to coordinate with an apple fan over the front door.

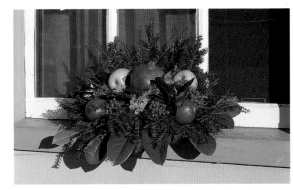

Hemlock, magnolia leaves, holly leaves, and scrub pine provide a pleasing contrast to the pomegranate, yellow and red apples, yarrow, and pepperberries.

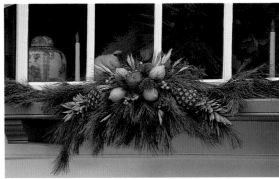

This windowsill arrangement of small ornamental pineapples, lemons, and apples also includes wheat, chinaberries, and bayberries against a background of white pine and red cedar.

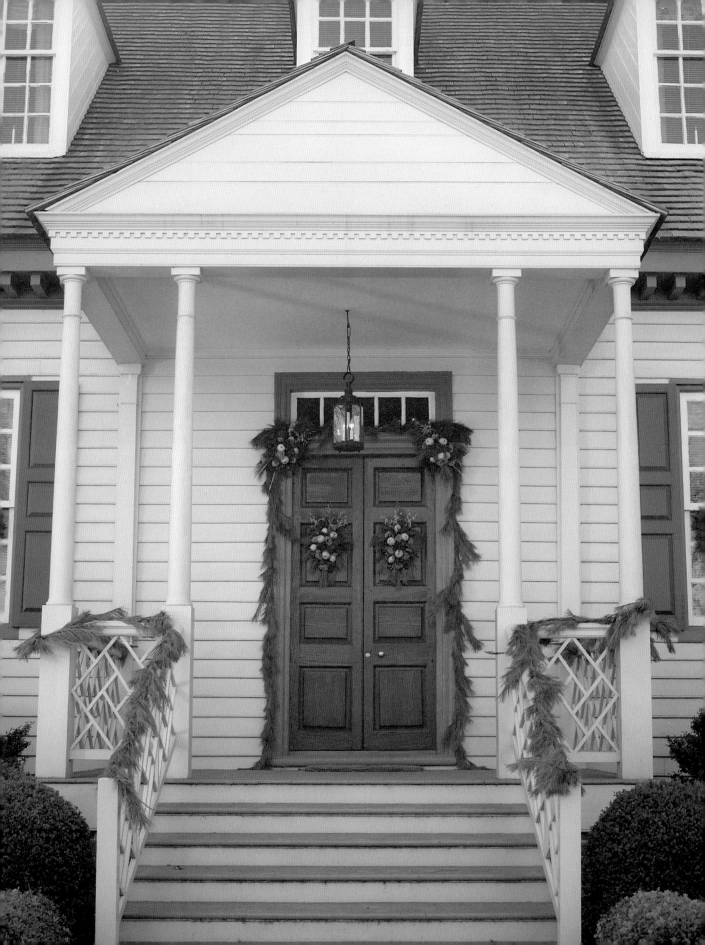

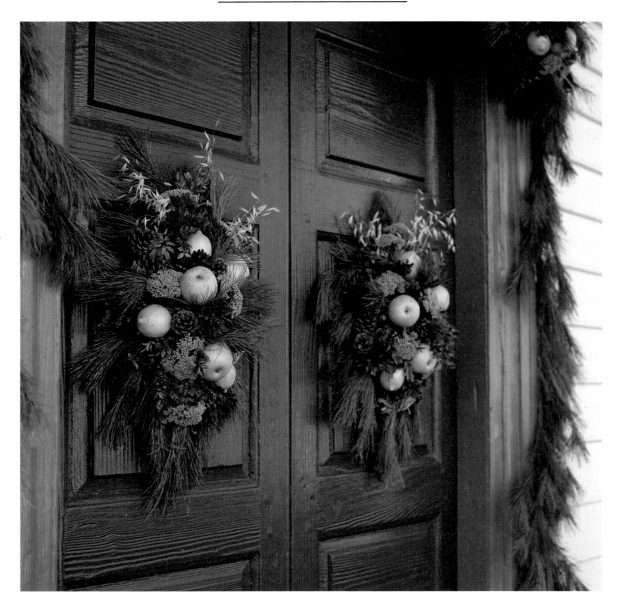

Two plaques in harmonious colors decorate the eighteenth-century double doors of Providence Hall House. On a backing of white pine and boxwood, lemons, golden delicious apples, yarrow, and sprays of oats with small Japanese black pine cones enliven these arrangements. Small fruit accents used on the roping above the door, wreaths on the windows, and roping on the railings lend a festive air to this lovely house.

How to Attach Fruit

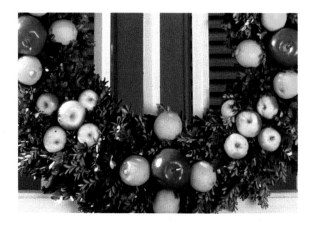

Supplies and materials needed: #16 or #18 gauge green floral wire, wire cutters, unwired green wooden floral picks, and fruits.

Fresh fruit may be attached to a wreath, plaque, roping, or window accents in two ways. When making a wreath, insert a 12-inch piece of #16 gauge floral wire (#18 gauge for small fruit) through the center of the fruit and bend the ends at right angles as shown. Insert these ends through the greens and twist them securely at the back. Cut off any excess wire. To show the flat side of an apple or other fruit, insert the wire from the bottom to the top. To show the top or bottom of the fruit, insert the wire across the fruit through the center as shown.

Fruit may also be impaled on various lengths of unwired wooden floral picks. Picks should be used if the base is a holder containing floral foam or if the wreath is especially large or

thick. As with the wire, impale the side opposite the outward face of the fruit.

Fruit may be cut in half so that the inside will be part of your design. Osage oranges may be sliced and dried for an interesting design. Pomegranates reveal an interesting pattern when cut, but dripping juice is a problem. After cutting a pomegranate in half, place the cut side down on several thicknesses of paper towels for 15 to 20 minutes to drain. If used whole, it is best to hollow out the pomegranate on the back or bottom with a melon scoop and fill it with pieces of newspaper or paper towels.

How to Wire Cones, Pods, Berries, and Nuts

Supplies and materials needed: wired green wooden floral picks, #20 gauge green floral wire, drill with 3/32-inch bit, clippers, wire cutters, and plant materials.

To wire cones: Attach a wired wooden floral pick to the cone by wrapping the wire tightly around the lower scales at the stem end of the cone and then around the pick several times as shown. Picks are usually used in floral foam and in thick wreaths of greens. Cones may also be wired onto pieces of #20 gauge floral wire and secured to the back of the frame when making a cone wreath.

To wire cotton bolls, okra pods, and other pods with stems: Attach a wired wooden floral pick to the plant material by wrapping the wire tightly around the stem and then around the pick several times as shown.

To wire lotus pods, milkweed pods, or other pods without stems: Make a small hole through the base of the pod with the #20 gauge floral wire

or with a sharp implement. To wire the pod onto a wooden floral pick, insert a piece of #20 gauge floral wire through the hole and twist it around the pick. To wire the pod onto #20 gauge floral wire, insert the wire through the hole and twist the wire around itself as shown.

To wire sweet gum balls, rose hips, chinaberries, and other berries: Gather a bunch of plant materials and wire them together as a bunch to a wired wooden floral pick or a piece of #20 gauge floral wire. Use several sizes of bunches as the last details of a decoration to add contrast and to fill in any empty spots.

To wire nuts: Drill a hole through the base of the nut with a small bit. Insert a piece of #20 gauge floral wire through the hole and twist the wire around itself as shown. Several nuts may be wired together in this way. Insert the wire through the wreath or roping and wire it to the back. The wire may also be wrapped around a wooden floral pick and inserted into a base of floral foam or Styrofoam.

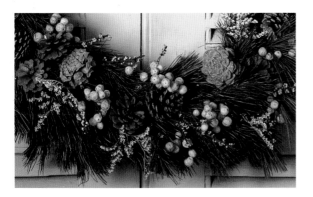

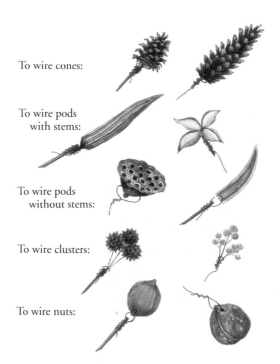

To wire cones:

To wire pods with stems:

To wire pods without stems:

To wire clusters:

To wire nuts:

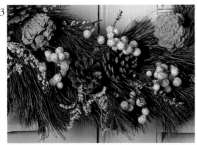

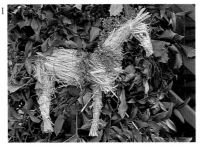

1. A straw horse garlanded with cedar berries and a mane of German statice on a background of Alexandrian laurel and holly foliage and berries. 2. A multitude of sugar cookie gingerbread boys tied with red yarn on a boxwood wreath.

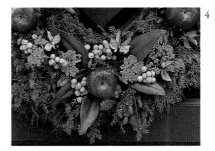

Two ways to use chinaberries. 3. Piñon and black pine cones combined with bayberries and German statice on a white pine wreath. 4. Red apples, yarrow, and cotton bolls placed on hemlock branches heavy with tiny cones and shiny magnolia leaf accents.

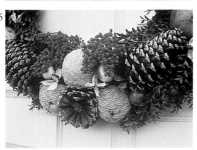

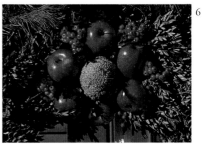

Osage oranges used on boxwood for dramatic effects. 5. Combined with longleaf pine cones, sprays of nandina berries, small lady apples, and cotton bolls. 6. Ringed by red delicious apples, pyracantha, holly berries, and white pine cones.

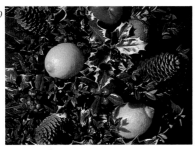

Wreaths of dried materials may be used year-round or put away for the next season. 7. Cinnamon sticks, a frosted rooster cookie made with an old cutter, German statice, cotton bolls, fresh holly, and rose hips. 8. Nuts, cones, and pods on a fresh boxwood wreath.

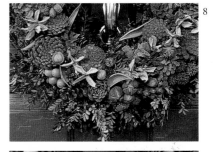

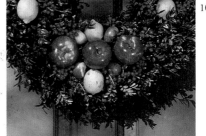

Lemons and apples used differently. 9. Lemons, an apple, a lime, spruce cones, tree boxwood, and variegated and Burford hollies contrast with magnolia leaves. 10. A precise arrangement of apples, lemons, holly berries, and lady apples on boxwood.

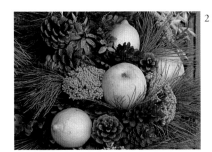

Yellow tones dominate two white pine and boxwood wreaths. 1. Lemons, oranges, chinaberries, lotus pods, and loblolly and black pine cones. 2. Golden delicious apples, lemons, yarrow, and scrub pine cones. White pine softens the edges.

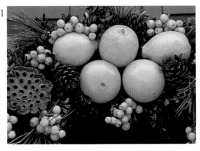

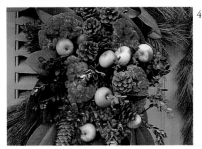

3. Loblolly, white pine, and spruce cones, dark ligustrum berries, Foster's holly foliage and berries, and dried wild grasses. 4. Glossy toothed leaves of longleaf holly contrast with red cockscomb, holly berries, lady apples, and black pine and spruce cones.

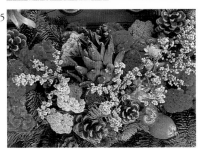

5. Dried materials on a balsam wreath include red and cream cockscomb, strawflowers, yarrow, artichoke, bayberries, and black pine cones. 6. Filberts, kumquats, cinnamon sticks, and bayberry contrast with glossy magnolia leaves on a balsam wreath.

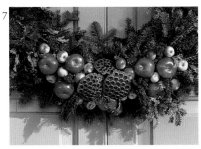

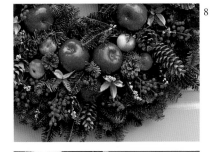

7. A balsam wreath trimmed with red delicious apples, lady apples, lotus pods, and dried sumac fruit. 8. A colorful combination of red delicious apples, lady apples, cotton bolls, sprigs of holly berries, bayberries, and white and black pine cones on balsam.

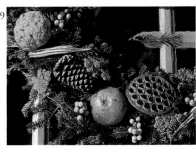

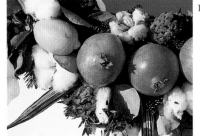

9. A balsam wreath features osage oranges, a pomegranate, chinaberries, yarrow, okra pods, lotus pods, and loblolly pine cones. 10. Pomegranates, lemons, cotton bolls, okra pods, and magnolia pods on a base of boxwood, lemon leaves, and balsam.

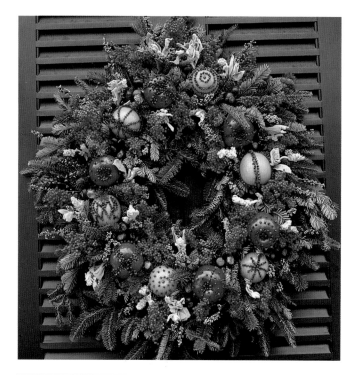

The boldly designed pomandered oranges and apples are imaginatively combined with bunches of bright pepperberries, lamb's ear, bayberries, and buckeyes and are nestled on a full balsam wreath.

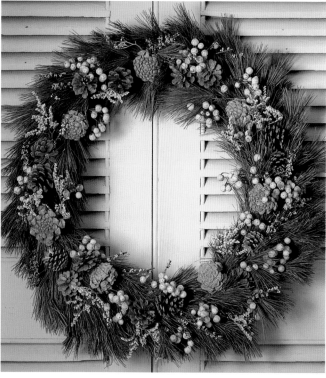

The subtle colors of piñon cones, black pine cones, chinaberries, German statice, and bayberries make an effective display on a delicate white pine wreath.

Opposite: The shop window at the John Greenhow Store reflects the Christmas spirit with a windowsill arrangement of holiday greens and fruit.

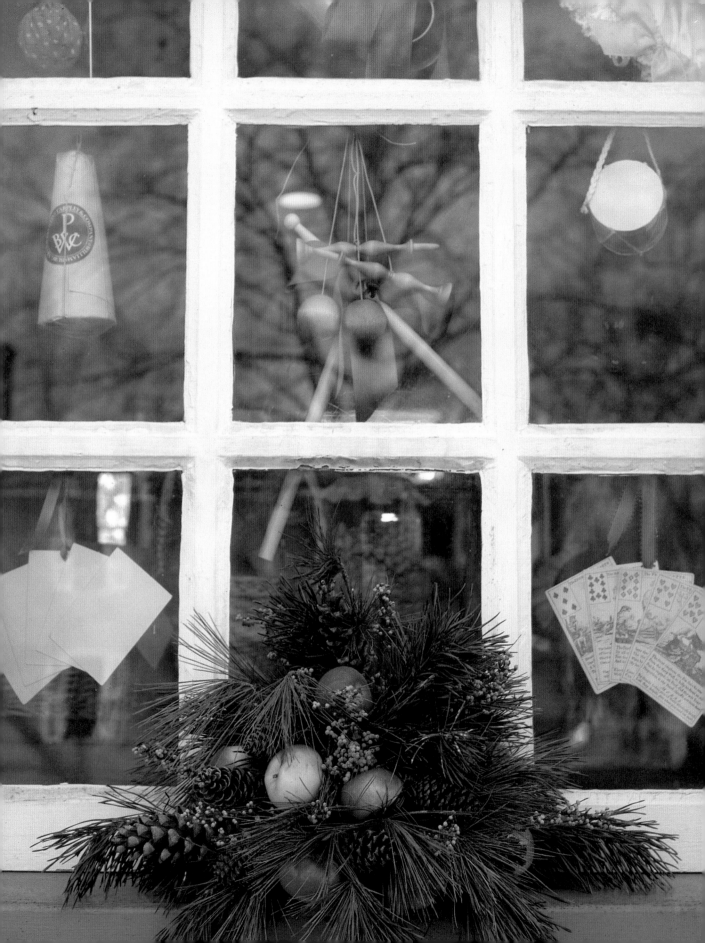

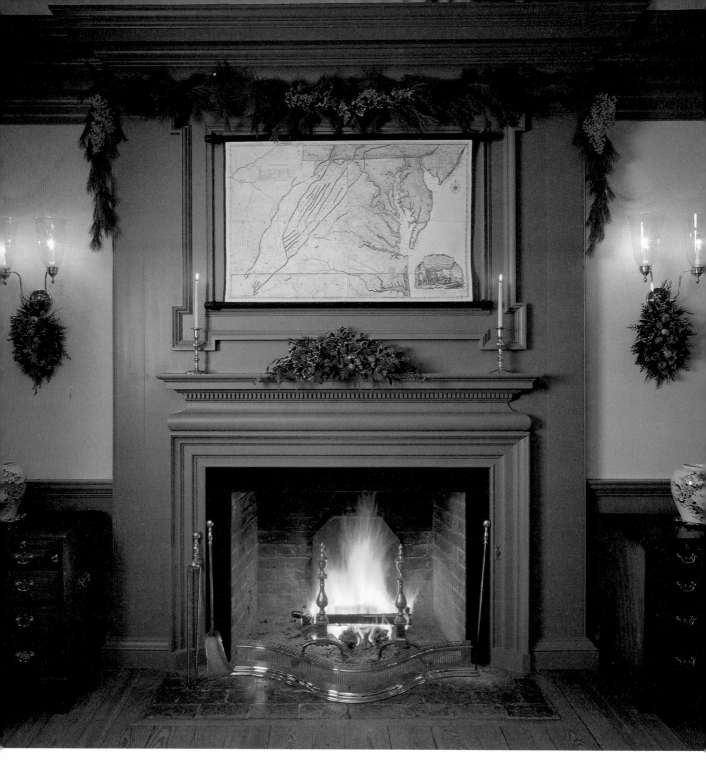

This inviting hearth at Craft House is decorated in the traditional Williamsburg manner. The colorful mantel arrangement of lady apples, arborvitae, English ivy, variegated holly foliage, and sprigs of bright holly berries; thick pine roping punctuated with variegated holly and large sprays of red nandina berries at the corners; and coordinated plaques of lady apples and greens hanging from the sconces—all welcome visitors to Virginia's colonial capital.

Mantels, Stairways, and Windows

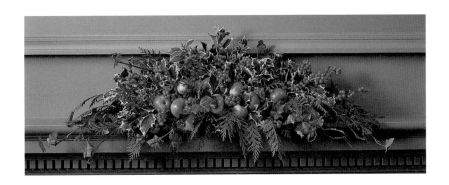

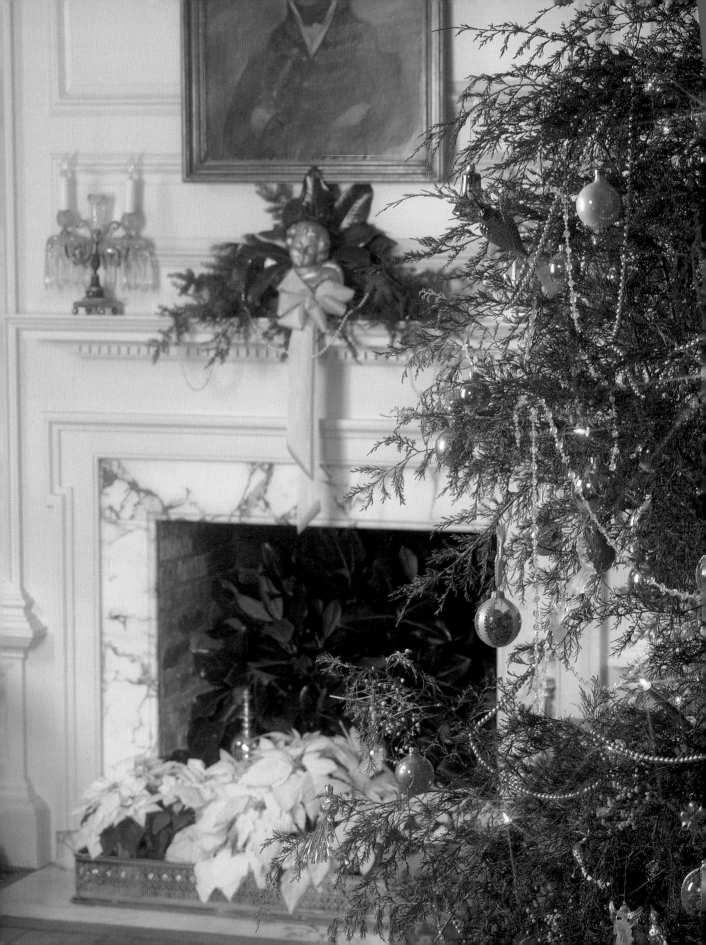

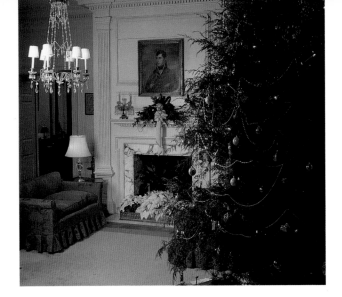

WILLIAMSBURG interior decorations reflect the Christmas spirit in many different ways: the map of Virginia above the fireplace at Craft House (overleaf) framed with colorful bunches of nandina and holly berries tucked into pine roping, dried garlands on each side of a painting at the Peyton Randolph House, the simple elegance of the mantel at Carter's Grove—all are here to inspire the visitor.

The wreaths, plaques, and garlands shown in the previous section can also be used indoors and combined in a mantel decoration with some of your personal treasures such as a toy and doll collection, a collection of brass candlesticks, or a favorite painting. Colors will often be determined by those used in a particular room, by a print or a painting, or by the style you favor in your decorating. Each element contributes to the festive air of the whole.

This room at Carter's Grove is elegantly complemented by a mantel arrangement of magnolia and hemlock with a gilded angel and large soft pink moiré bow. The fireplace is filled with cream poinsettias. The decorations and the tree with its heirloom glass ornaments recall the 1930s when the owners enjoyed many festive holidays here.

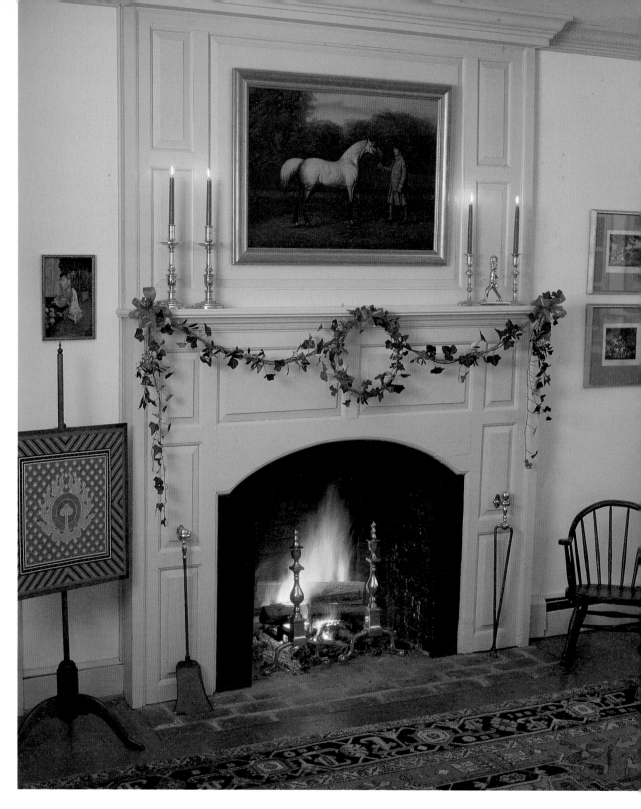

Inspired by the old English Christmas carol, holly and ivy are intertwined around the swags and wreath of Russian olive. The eighteenth-century fireplace paneling provides a suitable background for this delicate design.

How to Make a Swag and Wreath of Russian Olive

Supplies and materials needed: 3 1¼-inch nails with heads, hammer, #20 gauge green floral wire, clippers, wire cutters, ribbon for bows, 4-foot-long pieces of unbranched Russian olive (new growth is best) with thorns removed, conditioned English ivy (see page 136), and holly sprigs.

Drive a nail slanting upward at each corner of the mantel and another in the center. These nails may be painted the color of the mantel and left in place for future use.

To form the 2 swags, measure 4 straight pieces of Russian olive one-half the length of the mantel plus 10 extra inches to allow for the curve and shrinkage. Take 2 of these pieces of Russian olive and wire the ends together with #20 gauge floral wire. Leave a 4-inch tail of wire. Twine 1 of the pieces of the Russian olive around the other and wrap these ends with wire to keep them from unwrapping. Leave another 4-inch wire tail as shown below. Repeat this process for the second swag.

Make a curve in the 2 swags by carefully bending the branches with your hands until you form the desired shape. Be careful to make both curves similar. Cut the swags slightly longer than the correct length to allow for slight shrinkage as they dry. Twine a long piece of conditioned ivy around each swag and use the wire tails to secure each end. Use the remaining wire to attach these curved pieces to the small nails in the ends and center of the mantel.

To form the 2 vertical end pieces, wire together the ends of 2 pieces of conditioned ivy (approximately 18 inches and 24 inches long)

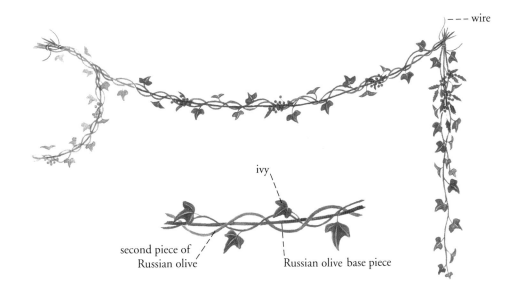

wire

ivy

second piece of Russian olive

Russian olive base piece

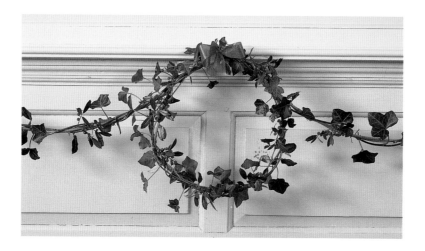

and a 12-inch-long holly branch with berries. Repeat this process for the second end piece. Hang an end piece from each corner nail. A bow at this joining point can be used to hide the mechanics.

To form the wreath, bend an approximately 3-foot-long straight piece of Russian olive with thorns removed into the circular size needed. Overlap the ends and wire them together with floral wire. Leave a 6-inch tail of wire. Twine a second, straight piece of Russian olive around this circular shape and secure the ends with the wire tail as shown below. Twine a long piece of conditioned ivy around the wreath and secure it

with wire. Trim the stem ends close to the wire. Attach a small loop of wire to the back of the wreath and hang it on the center nail between the 2 swags. Tuck small sprigs of holly with berries into the swags and the wreath as shown.

NOTE: Russian olive is used here, but any straight, unbranched pieces of saplings or vines of the lengths required and with diameters less than ½-inch thick could be used. The mantel shown is 72 inches wide. Therefore, the swag pieces were cut approximately 45 inches long. The size of your mantel will determine the exact lengths you will need.

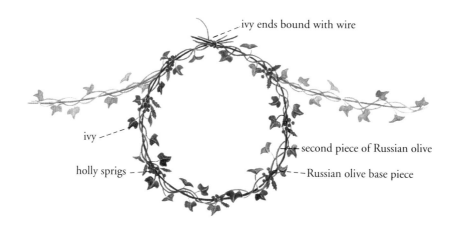

ivy ends bound with wire

ivy

holly sprigs

second piece of Russian olive

Russian olive base piece

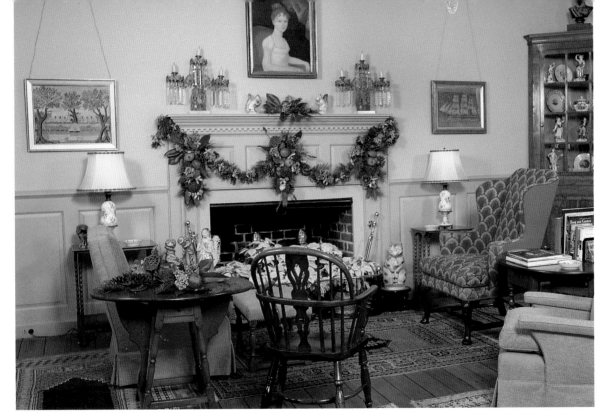

In the Morning Room at Bassett Hall, the fireplace is adorned with dried garlands and swags accented with dried pomegranates, hydrangea blooms, cotton bolls, cut and whole white pine cones, Japanese iris pods, daylily pods, lotus pods, walnuts, milkweed pods, fresh white pine sprigs, preserved magnolia leaves, and an assortment of other pods and cones. The colors used in the decorations reflect those present in this sunny room.

How to Make a Garland of Dried Pods and Cones

Supplies and materials needed: clothesline wire, wire cutters, 3 1¼-inch nails with heads, hammer, pliers, brown floral tape, #20 gauge green floral wire, and 3 wire coat hangers or similar wire.

This modern interpretation of the seventeenth-century wood carvings of plant materials by the famous English artisan Grinling Gibbons combines a variety of dried materials attached to a central wire. Sprigs of fresh white pine are added for contrast. The decoration consists of five sections: two swags, a center garland, and similar garlands at each end.

To form the 2 swags, measure the total length of your mantel and cut 2 pieces of heavy clothesline wire one-half this length plus 10 inches to allow additional length for the curve and for a loop at each end to hang the swag.

Drive a nail slanting upward at each corner of the mantel and another in the center. These nails may be painted the color of the mantel and left in place for future use.

Make a loop in one end of the wire with pliers. Bend the wire into a curve with your hands. Hang this curved wire by the loop to one end of the mantel. Tape the other end to the center nail to confirm that the shape and depth of the curve are satisfactory. Mark exactly where the second loop will hang from the center nail and make a loop with the pliers. Trim any excess wire. Repeat this process for the second swag. Check to see that both curves are similar, that they fit on the nails you have installed, and that both curves lie flat. Wrapping the wires with brown floral tape will help to conceal them.

Wire the pods and cones you have selected for the swags separately or in bunches with 4- to 6-inch pieces of #20 gauge floral wire (see page 29). Wrap the wire ends with brown floral tape. In this example whole and cut white pine cones and cotton bolls are used. Leaving both ends of these curved swag pieces undecorated so that the garlands will lie flat on top of them, start at one end of the clothesline wire and twist the wired ends of the pods and cones around it. Trim any excess wire. Repeat this process starting at the opposite end of the second wire. Hang both swags on the nails as shown below.

The center garland is a little fuller than the end garlands, but the process is the same for each. Straighten a coat hanger and make a loop at the top with pliers. Cut this piece of wire about 6 inches shorter than the length of the finished garland for your fireplace. Repeat this process with 2 more coat hangers. Wrap each piece with brown floral tape.

Wire the pods, nuts, and cones you have selected for the garlands separately or in bunches (see page 29). Wrap the wire ends with brown floral tape. Iris pod stems and hydrangeas do not need to be wired but are wrapped with brown floral tape.

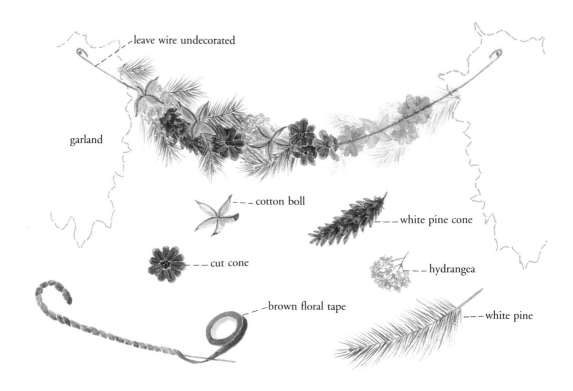

leave wire undecorated

garland

cotton boll

white pine cone

cut cone

hydrangea

brown floral tape

white pine

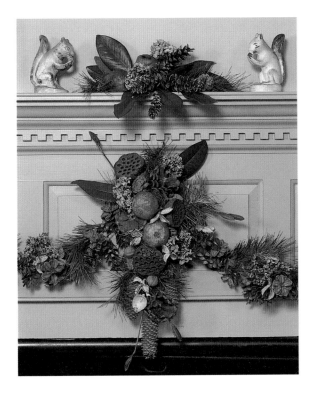

Start at the bottom and work toward the loop in the wire. Tape iris pods to the wire about 4 inches below the end of the wire as shown below. Attach the spruce cones next to conceal the main wire. Continue to twist the short pieces of wire around the main wire so that there are plant materials on each side of the wire as well as on top of it. The largest materials should be located toward the top center as shown below. Smaller nuts and pods may extend out to add depth and distinction to the design.

Loop the garlands over the nails. Add sprigs of white pine and dried hydrangea blossoms to the garlands and swags to add contrast and accent.

NOTE: This process may also be done in any shape for another location such as a tabletop wreath or garland or a garland over an archway.

NOTE: The dismantled arrangements will keep well if stored in a box with insect preventative.

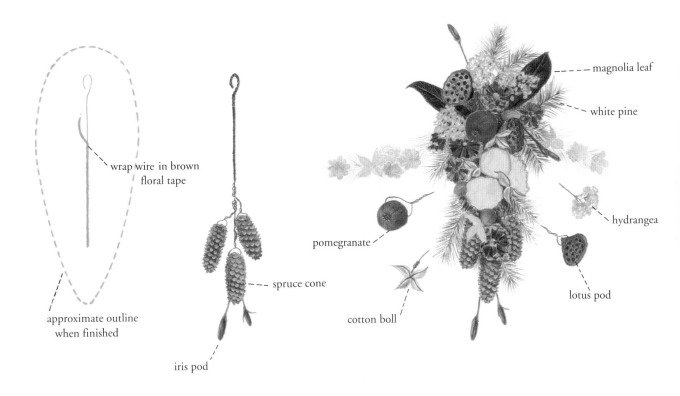

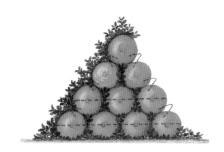

How to Make a Pyramid of Oranges or Other Fruit

Supplies and materials needed: strip of plastic, #16 gauge green floral wire, clippers, wire cutters, fern or greening pins, oranges, conditioned boxwood sprigs, and pyracantha berries.

A narrow mantel can present problems, but it is possible to create colorful and dramatic decorations similar to the one shown here.

In this example each pyramid is made with 10 navel oranges. They can also be made with other fruits and in different quantities. Pyramids of 6 lemons are pictured on page 130 on a mantel at the King's Arms Tavern.

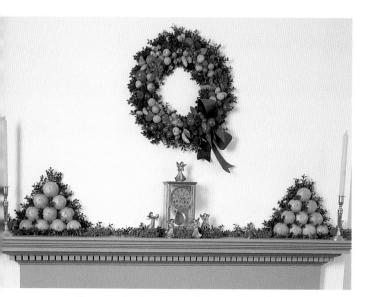

Pyracantha berries and pyramids of oranges outlined with boxwood repeat the vivid colors in the Della Robbia wreath.

Place a strip of plastic under the fruit to protect the mantel from juice.

Select the largest pieces of fruit for the bottom row. Push a piece of #16 gauge floral wire through 4 oranges, being careful to have the same side of all the oranges facing out as shown below. This will be the base of the pyramid. Push a wire through 3 more oranges and balance them on the bottom row. This row is secured to the bottom row with 3-inch pieces of bent floral wire or fern pins pushed at an angle from the top oranges down into the ones below. The next 2 rows of oranges are secured in the same way.

Fill in and outline the completed pyramid with sprigs of boxwood. Sprigs of pyracantha berries may be tucked in along the mantel.

This type of arrangement should be placed against a wall and should be slanted slightly backward to prevent it from falling forward.

How to Decorate a Permanent Wreath

It is convenient to have a permanent wreath to which fresh conditioned greens can be added each Christmas. Stored carefully, such a wreath will last many years. For this Della Robbia wreath, quality permanent fruits and several types of cones and nuts are wired onto a flat metal wreath form. Each year it may be edged with fresh boxwood on the inside and outside. Well-conditioned boxwood will last through the season. Remove the boxwood before storing the wreath.

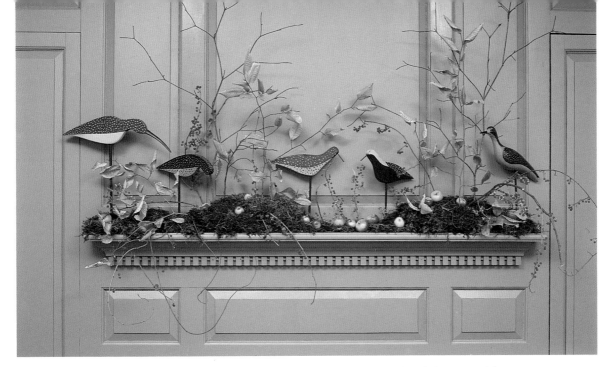

Colonial Williamsburg's reproduction shorebird decoys are nestled in beech leaves and bittersweet.

How to Create a Mantel Scene

Supplies and materials needed: 2 16-inch chicken feeders with top bar removed (or other narrow floral tray) containing floral foam and securely taped with green floral adhesive, strip of plastic, fern or greening pins, decoys on stands or sticks (or other appropriate objects), damp field moss, beech branches with leaves, other small branches, bittersweet, and small lady apples.

On this narrow mantel 2 small chicken feeders are filled with floral foam. These feeders come in a variety of lengths and may be painted the color of your woodwork. Here they will anchor the branches and bittersweet. Place a strip of plastic on the mantel to protect the woodwork from the damp moss. Position the holders and decoys. Cover the surface of the mantel and holders with the moss. Anchor the moss to the floral foam with fern pins. Cut the branches and bittersweet on a sharp angle and insert them into the floral foam, taking care to keep much of the weight at the back of the holders. If the arrangement has too much weight at the front, it will tip forward. You may wish to secure the holders to the mantel with wire.

After creating this woodland scene, small lady apples were placed at random over the surface of the moss. Other nuts and cones could be used. The branches and bittersweet were chosen for their appropriateness, color, and textural contrast with the soft moss.

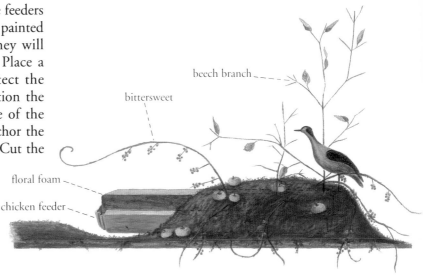

beech branch

bittersweet

floral foam

chicken feeder

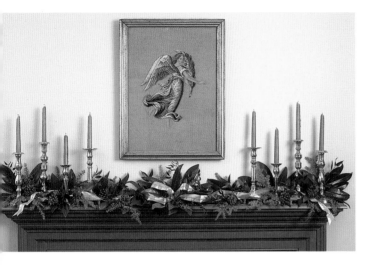

This striking nineteenth-century needlework angel worked in beads and thread was used at Bassett Hall by Mrs. John D. Rockefeller, Jr. The soft color of the bayberry candles is a good bridge between the muted tones in the needlework and the paint color of the mantel. They look very well in this collection of handsome brass candlesticks. In a simple but effective arrangement of magnolia leaves, Alexandrian laurel and the pale backs of the hemlock are used for contrast. A gold ribbon fluttering through the arrangement repeats the motion in the robes of the angel.

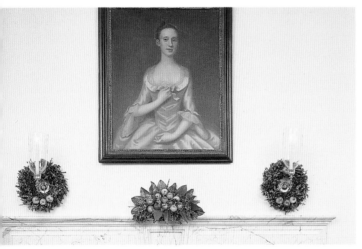

A formal mantel treatment complements the subject and subdued colors in this eighteenth-century portrait of a lady with a pink bow. Boxwood wreaths with bayberries and lady apples encircle the sconces. An arrangement of lady apples, boxwood, and bayberry sprigs is outlined with magnolia leaves and is made in a chicken feeder filled with floral foam. Magnolia leaves are added first. Lady apples impaled on wooden floral picks are added next. Boxwood and bayberry sprigs fill in voids.

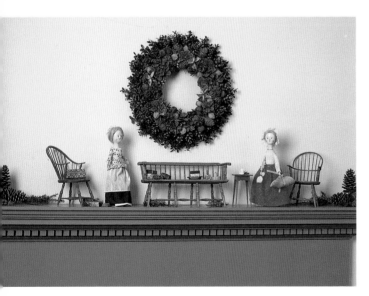

The Hagar Tyler dolls, furniture, and miniature wooden Noah's Ark and covered tureen on the table are popular items from Colonial Williamsburg's toy reproduction program. Here they are used in a charming arrangement under a mixed cone, pod, and nut wreath with boxwood sprigs tucked into the border. Loblolly pine cones, fraser fir, and pyracantha berries are added accents. Other favorite objects may be used to create an informal mantel composition.

This is an imaginative example of the use of non-traditional holiday colors dictated by the colors in the painting and in the wood trim. The dried pink roses, red grapes, s ᵗ blue-green dried hydrangeas, and the delicate trails of variegated ivy echo the soft hues and period of the painting. The woven wire basket mirrors the basket of the fireplace surround. This arrangement was made in a floral foam container placed in the basket. Wired floral picks are used for the grapes and hydrangeas. The dried roses, which have no stems, are positioned carefully on top of the grapes.

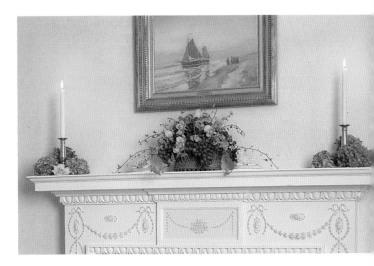

Dried garlands hang on each side of an eighteenth-century portrait of a child holding a dog. Where there is no mantel, garlands are successful solutions to this design problem. Each garland is made of materials chosen for a harmonious scheme. Okra pods, cotton bolls, strawflowers, and various other nuts and pods provide the light accents against the darker colors of the cones, dried sprigs of China fir, and the darker nuts and pods. Pieces of muted red cockscomb, dried red peppers, and fresh boxwood provide color. A cornhusk bow visually serves as the garland's hanger.

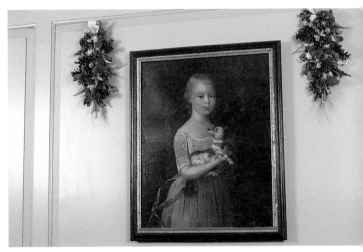

The pinks, greens, and yellows of this nineteenth-century theorem painting and figurines of The Seasons are repeated in an asymmetrical mantel arrangement of Alexandrian laurel, boxwood, yarrow, pink cockscomb, lemons, limes, and a pomegranate in a bedroom at Bassett Hall. The arrangement can be made in a chicken feeder or narrow floral foam holder. The basic line was established by the Alexandrian laurel and long-stemmed pieces of yarrow.

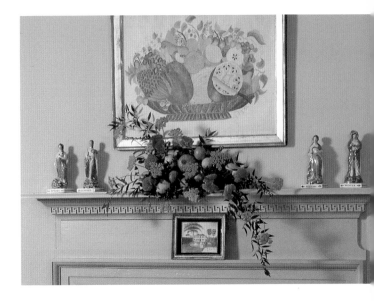

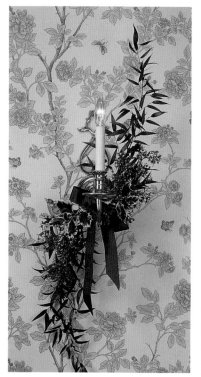

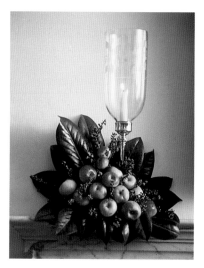

Lady apples are the focal point of this sconce design. A floral foam cage wired to the sconce is used to hold the border of magnolia leaves, lady apples on floral picks, and sprigs of bayberries.

The two sconces shown at Craft House are made in the same way but the different materials used cause the two to be very different. The delicate Alexandrian laurel foliage forms a soft curve that is repeated with sprigs of cedar berries and variegated holly. These soft gray-blue berries pick up the blues of the birds and butterflies in the wallpaper. A piece of wire and a dark green silk moiré ribbon attach the two parts of the swag to the sconce. Beside another mantel is a lovely curved swag of variegated holly and English ivy with sprigs of brilliant holly berries. The gold ribbon emphasizes the holiday colors.

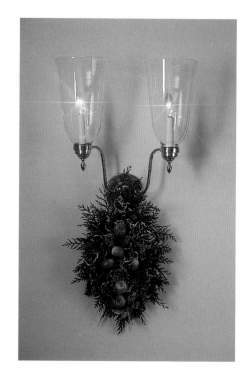

A bright colored oval sconce decoration at Craft House is designed to complement the adjoining mantel and pine garland. Arborvitae sprigs conceal the edges of the floral foam cage and frame the lady apples impaled on wooden floral picks, bunches of variegated holly foliage, and brilliant red berries in the center.

This well-proportioned sconce decoration is made in the standard way by overlapping the ends of two opposite facing branches of American holly and securing them to the arm of the sconce with wire and red ribbon. Here the contrast with the dark paneling is most effective.

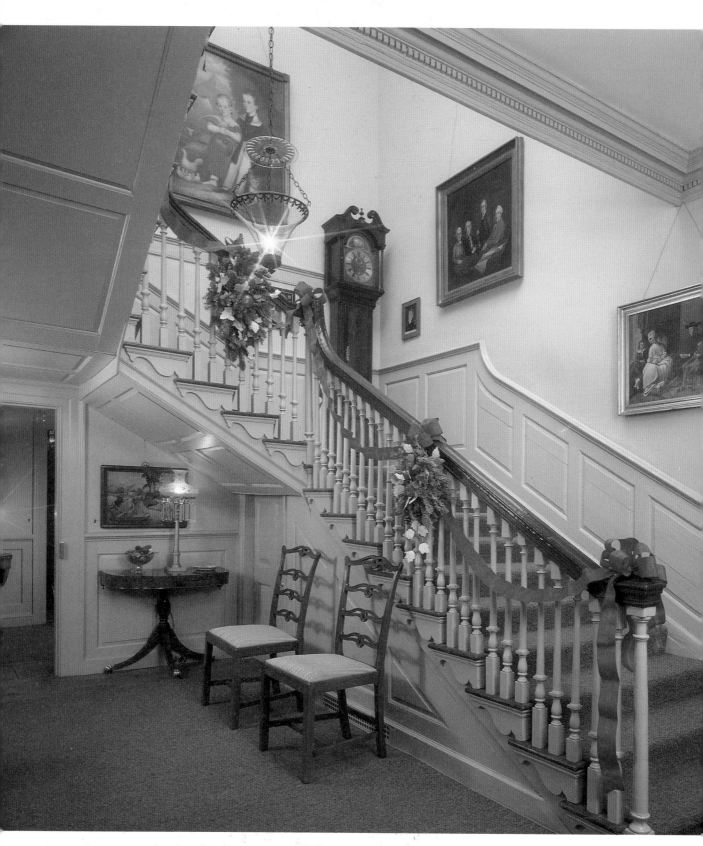

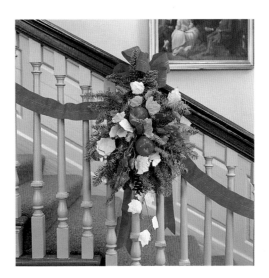

Stairways and Windows

Stairways and windows in Williamsburg are embellished in many ways. It would be difficult to find stairways better proportioned than those at Bassett Hall and Carter's Grove. Both are handsome architecturally and the quest is always to find an appropriate decorating idea to enhance the existing features. At the Peyton Randolph House the large Palladian window is outlined with pine roping and cones and invites a pleasing glimpse of the windmill. The cones, pods, and nuts added to the gracefully curved white pine and boxwood roping are complemented by the stairway and newel post accents at Providence Hall House. You may wish to try a plaque, garland, or some roping augmented with cones and pods exactly like ours, or something quite different but perhaps based on one of these forms.

The elegant stairway treatment at Bassett Hall is designed to serve as a dramatic accent in this hallway. Red moiré ribbons are used as roping and red apples and dried red peppers contrast with the silvery backs of the pressed white poplar branches.

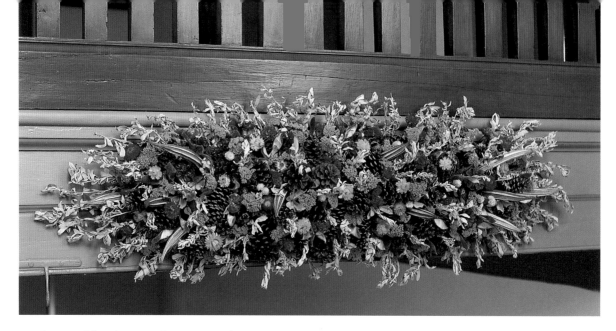

A plaque of dried materials contains silvery gray artemisia and the reds and yellows of strawflowers, cockscomb, globe amaranth, dried red peppers, and yarrow. Cotton bolls, okra and trumpet vine pods, and cones from loblolly, scrub, and white pines are used.

How to Make a Large Plaque of Dried Materials

Supplies and materials needed: block of Styrofoam 2 inches thick, wired and unwired green wooden floral picks, #20 gauge green floral wire, chenille wires or pipe cleaners, wire cutters, brown floral tape, and dried plant materials.

For this large plaque, use a lightweight Styrofoam block 2 inches thick and approximately 6 inches shorter in length and width than the finished size of the plaque you wish to make. The artemisia, strawflowers, globe amaranths, and small dried red peppers should be taped to 3-inch pieces of #20 gauge floral wire with brown floral tape as shown. The globe amaranths and artemisia may also be wired together in small bunches with stems approximately 3 inches long. The cotton bolls, cones, and pods are attached to wired wooden floral picks (see page 29). The yarrow may be used as is.

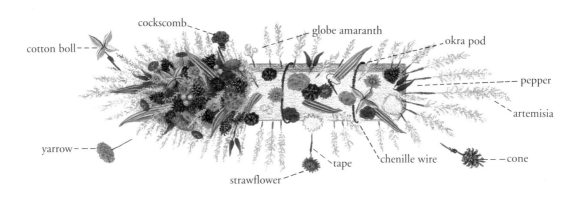

Depending on the size of your plaque, encircle the block of Styrofoam in 2 or 3 places with chenille wires made longer by securely twisting the ends together. The wires should go around the entire block and be twisted together in the back. They will be used to hang the finished arrangement. If your design exceeds 20 inches, encircle the block in 3 places with chenille wires.

Begin the design by filling in the 4 edges of the Styrofoam block with the pieces of artemisia as shown. Insert the cones next, followed by well-distributed okra pods, cotton bolls, and the remaining plant materials. Cover all parts of the Styrofoam. Hang the plaque from the chenille wire loops on the back.

NOTE: Dry floral foam cages can be used for small forms, but Styrofoam is very lightweight and is available in large sizes.

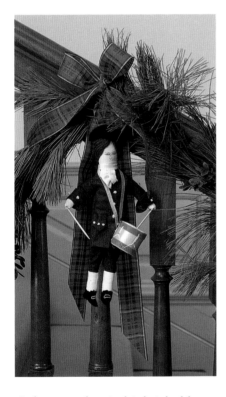

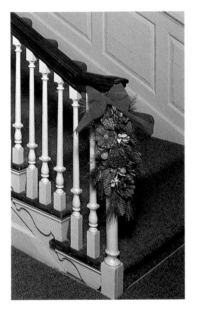

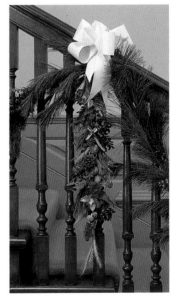

A drummer boy in his bright blue uniform is one of several dolls from Colonial Williamsburg that are tied to this stairway roping with bright red tartan bows.

These two accents are both made of dried materials attached to a central wire but look very dissimilar due to the different sizes and variety of materials used. *Left:* This wide garland of lotus pods, large cut pine cone flowers, and Norway spruce cones is lightened with the addition of cotton bolls and walnuts. The white pine sprigs add a touch of green. *Right:* This long, narrow garland is made with a large variety of materials: sweet gum balls, trumpet vine and poppy pods, bits of cockscomb, beech leaves, dried China fir sprigs, wheat, walnuts, cotton bolls, and scrub pine, deodar cedar, dawn redwood, and other cones.

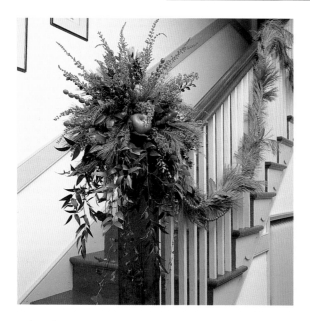

This dramatic newel post with its bright spikes of wired cranberries, heather, Granny Smith apples, and cascades of ivy, periwinkle, and Alexandrian laurel is filled in with white pine and boxwood. A cranberry chain twists around the white pine and cherry laurel roping decorating the stairs.

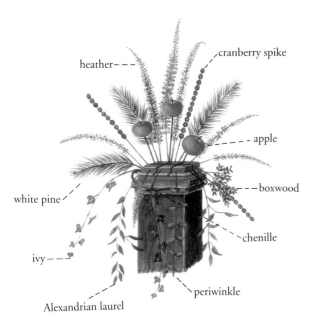

heather
cranberry spike
apple
boxwood
chenille
white pine
ivy
periwinkle
Alexandrian laurel

How to Make a Newel Post Decoration

Supplies and materials needed: floral foam, small plastic floral foam tray, 5" x 4" (available at floral supply outlets), green floral adhesive tape, chenille wires or pipe cleaners, #16 gauge green floral wire, wire cutters, unwired green wooden floral picks, conditioned greens (see page 136) including some long pieces suitable for trailing, heather, cranberries, and Granny Smith apples.

Soak the floral foam and cut it to fit the tray. Secure the floral foam with tape as shown. Make long pieces of chenille wires by twisting several ends together. Attach these wires to the edge of the holder and secure it to the top of the newel post. These wires will not harm your woodwork. Be sure the holder is securely anchored from both sides due to the weight of the materials used in the arrangement.

Insert several long pieces of ivy, periwinkle, and Alexandrian laurel around the base, especially in the front, to trail out of the container and down the post. Arrange the heather so that it is evenly distributed. Thread cranberries on pieces of #16 gauge floral wire and insert the wires evenly into the floral foam. Impale the apples on floral picks (see page 28) and insert the picks into the floral foam. Place the two outside apples lower and the middle one higher as shown. This will help stabilize the arrangement and strengthen the design. Fill in with the Alexandrian laurel, boxwood, and white pine sprigs as needed to conceal the holder and give a pleasing full look to the arrangement.

A small floral cage is used to hold this collection of subtly colored dried pods and cones in place. Okra pods and white pine cones are softened with sprigs of boxwood and white pine. Garlands matching those shown as stairway accents hang from each side of the newel post.

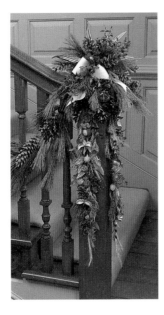

A grapevine wreath and garland (below) make an unusual decoration on this stairway at the George Wythe House. Arranged in small nosegays along the gently curving grapevines are red and cream strawflowers, dried red peppers, scrub pine cones, cotton bolls, Japanese iris pods, halves of locust pods, various nuts, and lotus pods. The individual parts of these nosegays can be wired or attached to the vine garland with a hot glue gun.

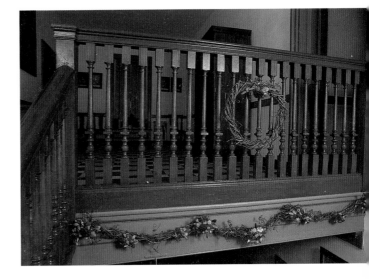

Roping and Garlands

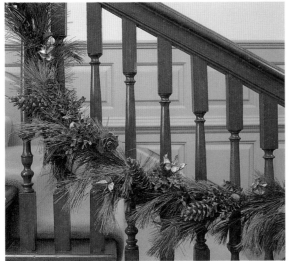

Pine roping is usually available during the Christmas season if you do not wish to make your own. It is easy to make plain roping more distinctive by adding additional plant materials.

The gracefully curving white pine and boxwood roping used on the long staircase at Providence Hall House is embellished with cotton bolls, sweet gum balls, okra pods, walnuts, and cones from hemlock, white pine, and deodar cedar. A different effect could be produced by adding sprigs of Alexandrian laurel, boxwood, rose hips, and variegated holly. Another idea might be to wire together and add several bunches of holly berries, chinaberries, or wired fruits. To do this, carefully lift the foliage ends of the pine and wrap the wired materials securely around the core of the roping. The needles can be rearranged around these added materials.

Opposite: This view from the second floor at the Peyton Randolph House toward the windmill reveals a lovely pine cone wreath garnished with cotton bolls and white pine hanging from the banister. Pine roping with clusters of cones and pods frames the handsome arch of the large Palladian window where a balsam wreath hangs on a festive red ribbon.

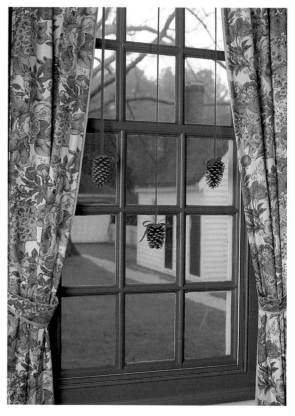

Through a window at Carter's Grove we catch a glimpse of a kitchen decorated for the holidays where cheerful gingerbread boys hang from bright ribbons.

The idea to hang cones on ribbons, shown here at Bassett Hall, was inspired by a 1930s magazine article on holiday decorating and has been used during the past years to interpret the period when the Rockefellers were in residence. Ribbons attached with carpenter's tacks to loblolly pine cones are hung from the upper window frame.

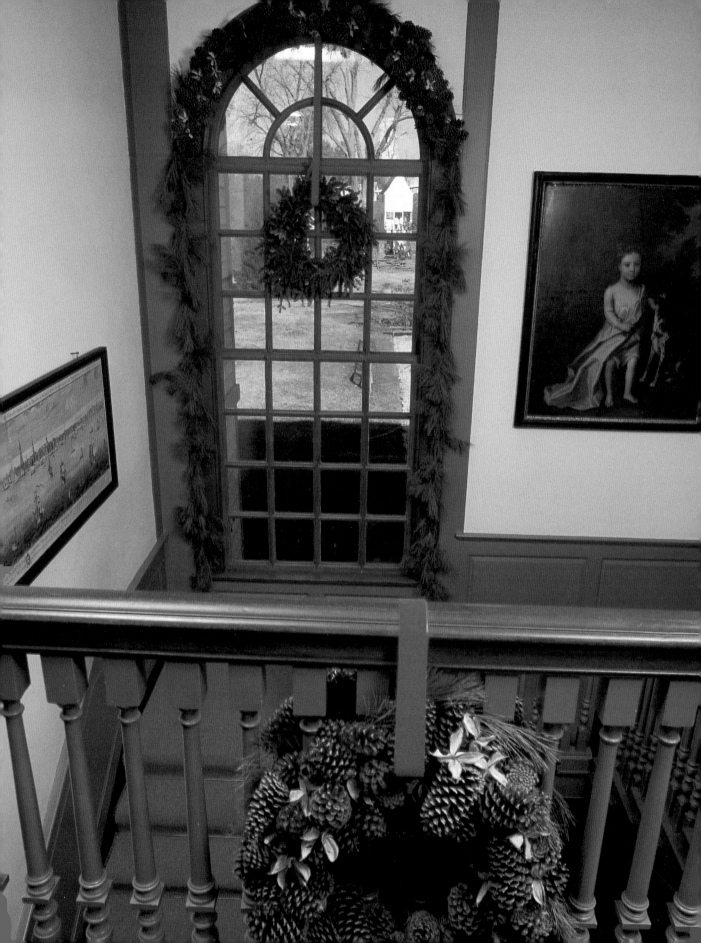

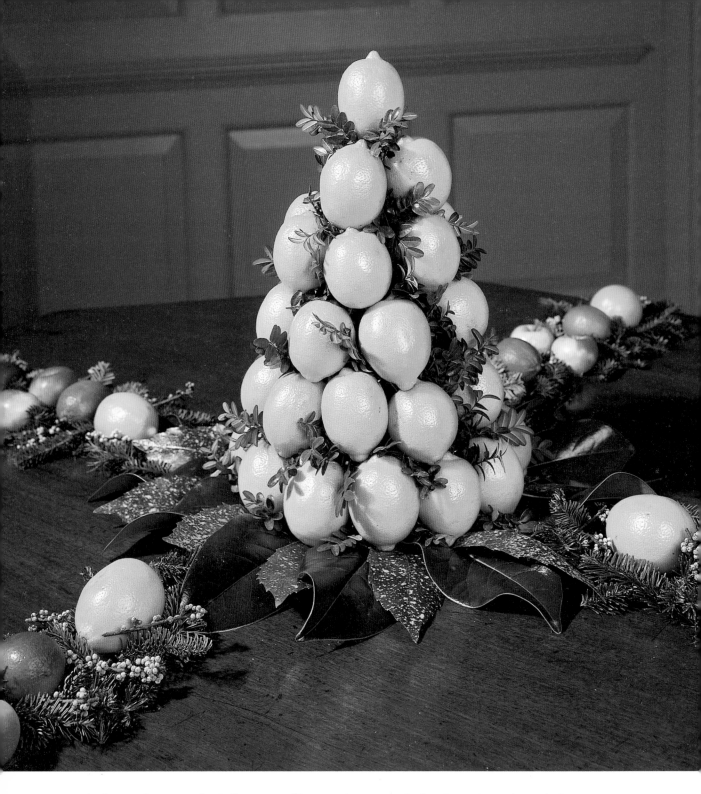

An impressive cone of spiraling rows of lemons sits on a bed of variegated aucuba and glossy magnolia leaves with radiating spokes of balsam, lemons, limes, lady apples, and bayberries. Boxwood is added between the lemons.

Cones, Topiaries,
and
Kissing Balls

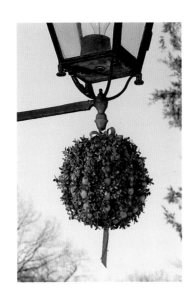

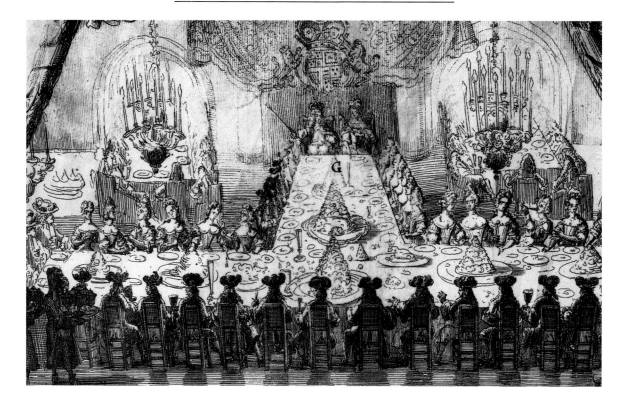

COLONIAL WILLIAMSBURG has long been known for its elegant cone decorations, most especially for the apple cone. This way of arranging fruit has been popular for many years and is shown in this early Dutch print commemorating a seventeenth-century banquet in London for Charles II. Now, instead of using solid fruit or cookie cones on the dining table as part of a course, ours are purely decorative.

There are three basic forms on which cones can be made: a nail-studded wooden cone, a wire mesh cone filled with sphagnum moss or floral foam, or a Styrofoam or paper cone. You can also purchase a tree with wire branches to decorate. The choice of which form to use is determined by the materials you will be using.

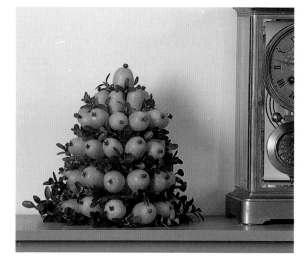

Clove-studded kumquats are arranged in vertical rows with the stem ends facing out.

How to Make a Fresh Fruit Cone on a Nail-Studded Wooden Form

Supplies and materials needed: Colonial Williamsburg's nail-studded wooden cone form, heavy cardboard, scissors, plastic film, cellophane tape or masking tape, clippers, conditioned plant materials (see page 136), fruit, and nuts.

Nail-studded wooden forms are used when making fresh fruit cones. The fruit is impaled on the nails in various designs or randomly. Whether the design is formal or free in feeling, it is unified by placing boxwood sprigs or other greens between the fruits to conceal the wooden form. The cone is usually placed on a cardboard circle edged with magnolia leaves for an attractive finishing touch. It may also be raised on a pedestal base.

To make the cardboard base, cut a circle of heavy cardboard approximately 3 inches larger than the diameter of the base, wrap it with plastic film, and tape the film to the cardboard. When making a base for a cone that will be placed directly on a table, trim off the stem ends of magnolia or other large, glossy leaves and tape them in an even row around the edge of the cardboard circle. If the cone will be placed on a pedestal, do not include the last step but tuck in greens around the base once the finished cone has been placed on the pedestal. In either case, place the cone form on the cardboard circle before impaling the fruit. It is easier to make the cone and safer to move it once it is placed on this base.

When using one type of fruit, impale the largest pieces of fruit at the bottom and save the smallest pieces for the top row. The largest piece of fruit, or a different fruit, can be used at the center top. The fruits may be arranged one above another in vertical rows (kumquat cone), alternated (apple cone), or in spirals (lemon cone). You should be consistent regarding the placement of stems. Fill in with boxwood sprigs or other greens as needed.

When making a mixed fruit cone, start with the largest fruits and impale them randomly and at different angles, add smaller fruits next, and end with the smallest fruits, nuts (see page 29), and greens. The nuts may be anchored into adjacent fruit by their wires. Impale the largest piece of fruit on the top of the form or use a pineapple or its top for the focal point. Fill in with greens as needed.
NOTE: Flowers, pine, holly, cedar, or other bushy foliage may be used to fill in the spaces.

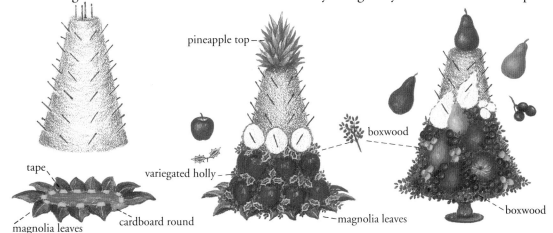

tape

magnolia leaves

cardboard round

pineapple top

variegated holly

boxwood

magnolia leaves

boxwood

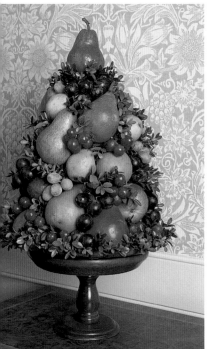

1

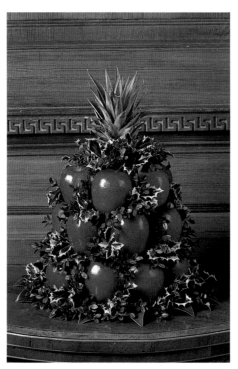

2

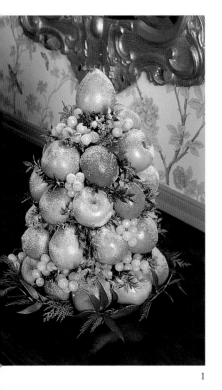

3

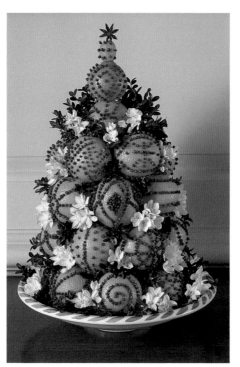

4

1. A striking cone of green apples, pears, limes, and grapes is made in a random arrangement and placed in a pewter strawberry bowl. Alexandrian laurel and cedar sprigs are tucked in at the bottom, tree box sprigs are used between the fruits above, and the whole cone is dusted with sugar. A delectable sight!

2. The classic Williamsburg apple cone—with a pleasing twist. Variegated holly sprigs give a unique look to this cone of alternating shiny red delicious apples on a magnolia leaf base. Boxwood sprigs are added with the holly sprigs and pineapple foliage is used on the top.

3. A pedestal raises this distinctive cone of red and bronze pears and green, red, and purple grapes. The fruits and colors are arranged at random and boxwood is added at the base and throughout the cone for contrast and to fill in areas between the fruits.

4. A dramatic cone of pomandered oranges not only smells delightful but is decorative as well. Alternating pomandered navel oranges are organized in rows, with a smaller orange at the top followed by a clove-studded kumquat topped with a star anise. Fragrant narcissus blooms, which resemble elegant orange blossoms, are tucked in with the boxwood.

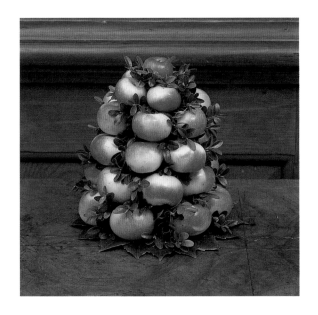

Here another cone is made on a small nail-studded wooden form. Tiny lady apples on a base of aucuba leaves are arranged in a spiral design with boxwood sprigs tucked in for accent.

How to Make a Dried Flower Cone on a Wire Tree

A colorful cone of dried flowers on a pedestal base is an attractive addition to any room. Plant materials include various colors of roses, rosebuds, and cockscomb, German statice, baby's breath, globe amaranth, bayberries, yarrow, artemisia, larkspur, zinnias, strawflowers, and various other everlastings. The base of this cone is a purchased tree with movable wired branches. Any size tree may be used. All of the dried plant materials may be attached to the tree with white glue or a hot glue gun. When using a hot glue gun, be sure to remove all of the strings left by the glue. Keep turning the form to ensure balanced placement of the dried plant materials.

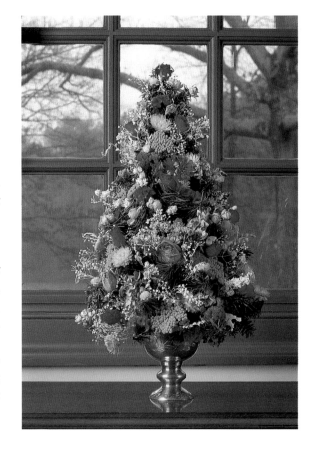

How to Make a Cone on a Wire Mesh Form

Supplies and materials needed: chicken wire, #20 gauge green floral wire, clippers, floral foam or sphagnum moss, plate, unwired green wooden floral picks, conditioned plant materials (see page 136), fruit, nuts, and cones.

This method is appropriate when using fresh plant materials, but it can also be used when your materials are dried. The cone is made of chicken wire, based on the directions below. For instance, if you want a finished cone 14 inches tall, the cone form should be approximately 12 inches tall. The cone form shown is 12 inches tall and 7 inches in diameter. The cone may be made narrower if you increase the overlap at the base.

It is easiest to make a paper pattern first. Adjustments are quickly made, and, once made, this becomes the pattern for the wire form.

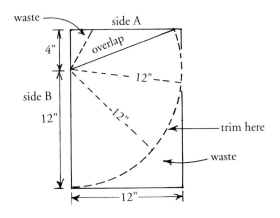

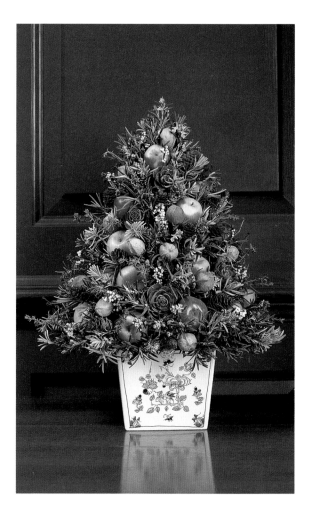

This herb-filled cone contains fragrant rosemary, lavender, and thyme. Lady apples, small black pine cones, nuts, and bayberries are added for accent.

Mark approximately 4 inches in on side B of the 16-inch side as shown. Measure 12 inches from this mark starting with side A to side B in a curved line. Trim excess from curved bottom. Bend into a cone shape and use tape to secure the form temporarily and check the size. Use this pattern to cut out the wire.

After forming the wire cone shape, be sure that it is securely wired together and that the length from the top to the bottom is equal on all surfaces so that the cone will sit evenly.

For fresh materials, the center is filled with soaked floral foam or wet sphagnum moss. Use dry floral foam or dry sphagnum moss for dried materials.

Once the form is stuffed, place it on a plate with a slight lip that is a little larger than the base of the cone form to catch any excess water.

You are now ready to add the plant materials. The predominant materials of this cone are fresh rosemary, lavender, and thyme. Cut 4-inch sprigs from your conditioned materials and strip the leaves off the bottom 1½ inches of the stems. Insert the herbs into the wet floral foam or moss. When the form is evenly covered with herbs, impale the lady apples on the unwired floral picks (see page 28) and insert the picks into the floral foam. Wire the nuts and cones to floral wire (see page 29) and insert the wires into the floral foam. Turn the form to make sure that the materials are evenly distributed. Add the bayberry sprigs for accent.

This cone is shown placed on a delft jardiniere reproduced by the Colonial Williamsburg Foundation from an English flower holder made about 1750.

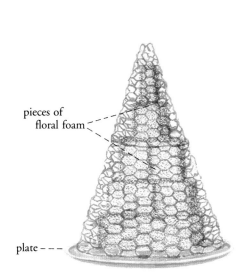

pieces of floral foam

plate - - -

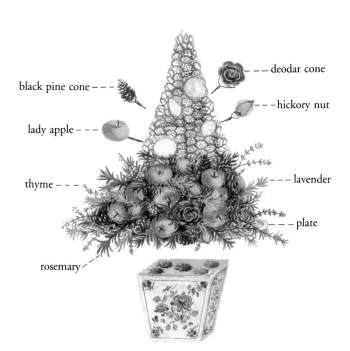

black pine cone - - -

deodar cone - - -

hickory nut - - -

lady apple - - -

thyme - - -

lavender - - -

plate - - -

rosemary

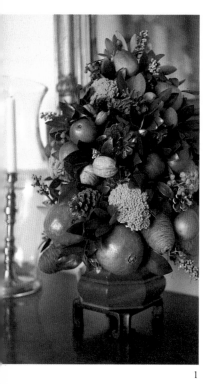

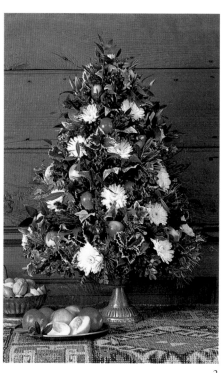

1

1. This striking cone form made in a tea caddy includes an unusual combination of materials. Pomegranates, limes, Seckel pears, yarrow, and bayberries are used with pyracantha berries, nuts, cedar cones, and cleyera leaves on wooden picks that have been inserted into the form.

2. Boxwood, Alexandrian laurel, and white pine serve as the background for this wire cone. Variegated ivy and holly and white cushion mums are accents while the lady apples lend color. The reds and yellows of the nectarines beside the cone nicely echo the colors of the lady apples.

2

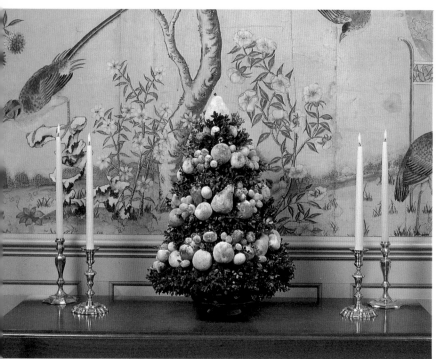

3

3. At the Lightfoot House, a large boxwood cone topped with a sugared pear is placed on a ceramic base. Spirals of sugared fruits, shown in the close-up opposite, reveal the subtle relationship and appropriate soft colors chosen to be used with this antique hand-painted wallpaper. Pears, nectarines, lady apples, strawberries, and grapes are some of the fruits that are impaled on floral picks and inserted into the floral foam.

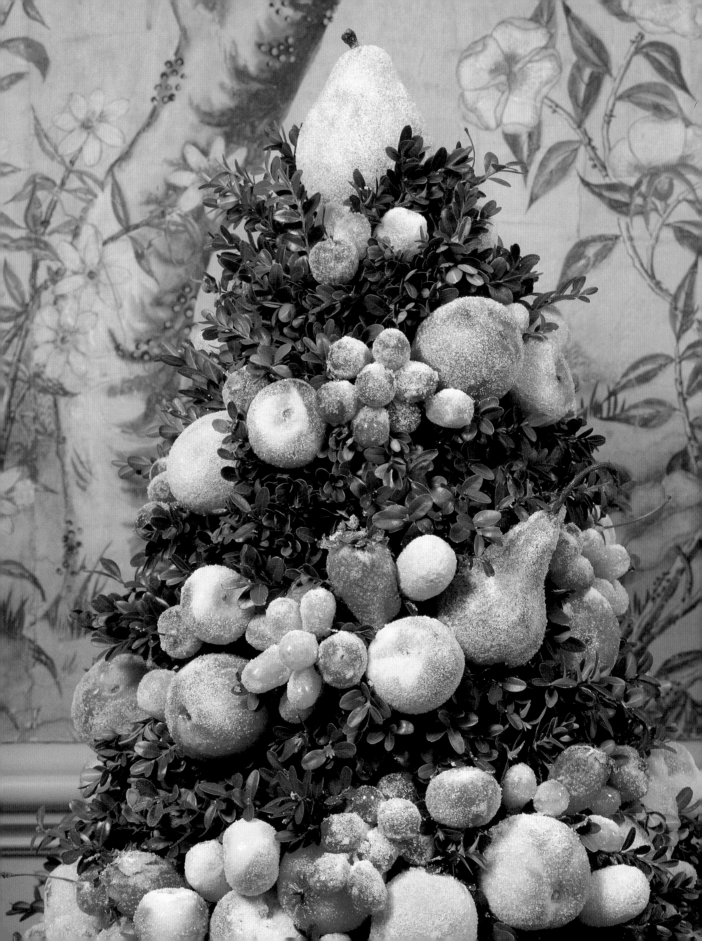

How to Make a Cone on a Styrofoam or Paper Form

Supplies and materials needed: Styrofoam or heavy paper cone form, hot glue or thick white glue (suitable for use on Styrofoam or paper),

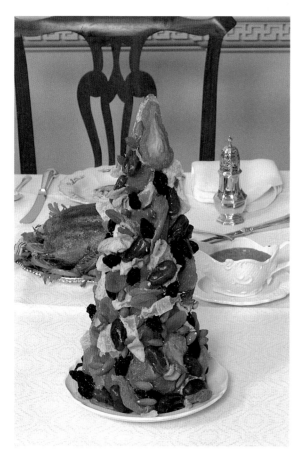

Balancing pairs of dried fruit cones were a frequent choice of the eighteenth-century hostess when decorating her table for guests.

cellophane tape or masking tape, and materials to be used to decorate the form.

Here we show an unusual variety of cones that may be made on a Styrofoam or paper cone. This type of form is used when gluing the material with hot glue or white glue. In this example dried fruits have been attached with thick white glue in a random pattern.

Styrofoam may also be used to create unusual shapes or very large sizes. To create the giant apple cone (right), large blocks of Styrofoam were glued together and trimmed into a pair of large cones. These cones were placed on plywood rounds that were cut approximately 6 inches larger than the bottom of the form to support the first row of apples.

To make a paper cone from a piece of poster board or other heavy paper 12 inches by 16 inches, mark approximately 4 inches in on side B of the 16-inch side as shown on page 64. Measure 12 inches from this mark starting with side A to side B in a curved line. Trim excess from curved bottom. Bend into a cone shape and secure with glue or tape on the inside of the cone. To decrease the diameter of the bottom, increase the overlap.

The dried materials may now be attached with white glue or hot glue. Keep turning the form to ensure the even distribution of all materials. Note the carefully arranged roses and hydrangeas on the facing page.

1. Dried hydrangea blooms and dried roses in soft colors were assembled to make a delicate tall narrow cone. In this example, white glue was used to adhere the plant materials to the cone.

2. This cockscomb cone at Bassett Hall was formed using soft pink colors to echo the colors of the room. Glass bird ornaments with spun-glass tails dot the surface. The cone is placed in a woven ceramic container.

3. In the kitchen at Carter's Grove, loblolly pine cones are arranged in a random manner over the surface of a large, wide cone. Hot glue holds this type of material well. Popcorn is glued in the nooks and crannies and adds a delightful contrast with the dark cones.

4. Instructions for making the form for this giant cone of apples at Craft House are given on the preceding page. The cone is covered with large apples that have been impaled on long unwired wooden floral picks and inserted into the Styrofoam form. Conditioned boxwood conceals the spaces between the apples. Because of its considerable weight, the cone was made in place on the large garden urn.

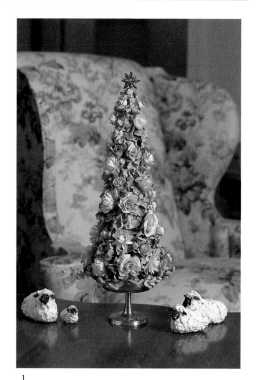

1

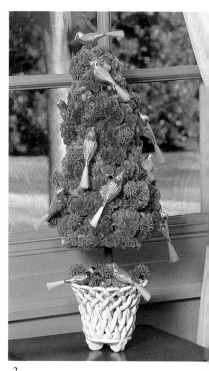

2

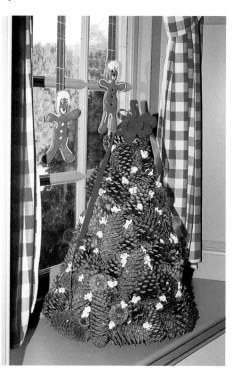

3

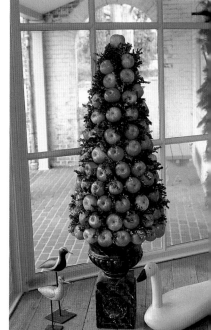

4

A cone of whipped cream and sugared rosemary sprigs is a delightful surprise to find on a holiday table. Synthetic whipped cream should be used because a stabilizer is present that keeps the cream in place. Starting at the bottom of the form, the cream is spread onto the cone with a knife using slight upward swirls. Sugared rosemary sprigs are added to resemble branches peeking out from under a blanket of snow.

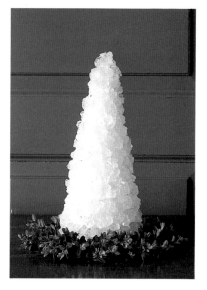

Rock sugar crystals sparkle and resemble glistening ice when glued to this cone. A pair of these are alternated on the tables at the Palace and Craft House with a pair of whipped cream cones. First the crystal chunks were broken into smaller pieces and glued onto the form. Next tiny bits of the candy were used to conceal any glimpse of the base. The finished cone may be sprinkled with powdered sugar to give it the look of being dusted with fresh snow.

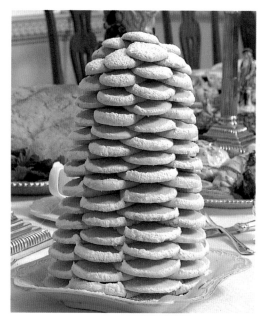

Decorative stacks of cookies sprinkled with powdered sugar on the Palace supper table make a dramatic presentation and recall the Dutch print shown on page 60. The arrangement of foods on eighteenth-century tables was structured, and detailed accounts exist showing such cones to be fashionable. These cookies may be held together with royal icing to make a more permanent decorative cone.

Opposite: A glorious and dramatic cone of various breads in the kitchen at Carter's Grove is decorated with colorful sprigs of holly. The breads may be impaled on wooden floral picks and inserted into the Styrofoam or this cone could be made entirely of breads fastened together with wooden picks or toothpicks.

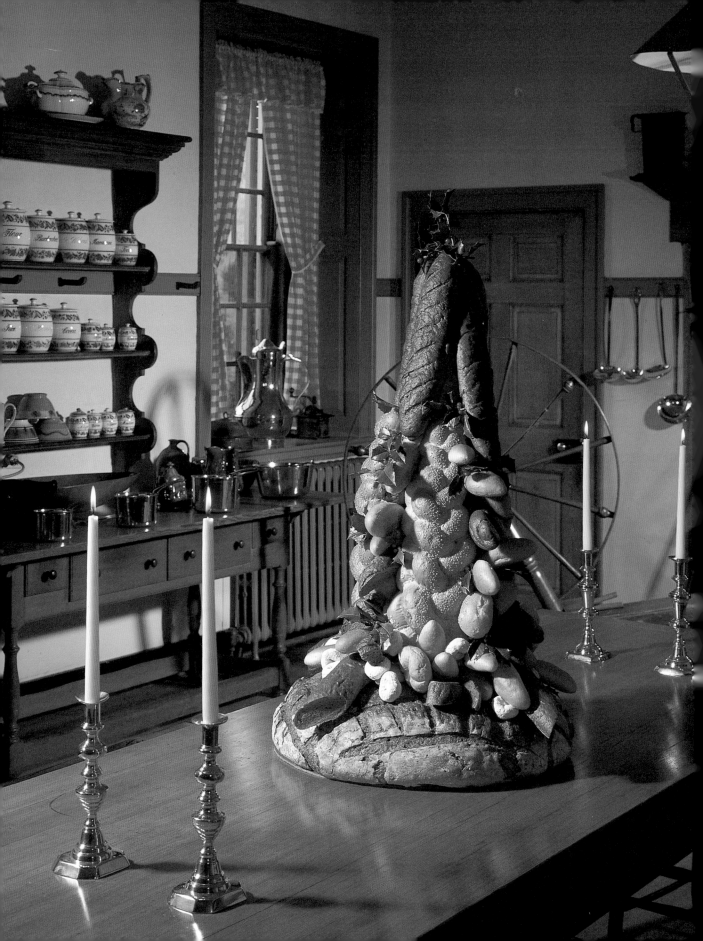

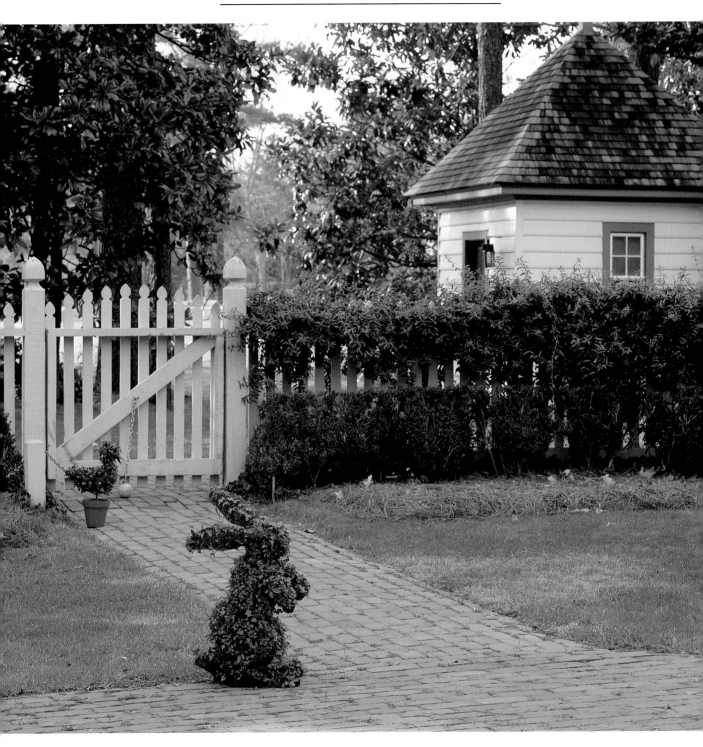

A delightful large bunny and a small ivy-covered duck watch over a Williamsburg garden.

Topiaries

Topiaries were a favored form of decoration in Roman times and have seen a resurgence in popularity recently, especially in the movable forms.

Many variations have evolved over the centuries and the current popularity of topiaries — real and "mock"—shows them to be an especially versatile form. Some are planted in pots, some in moss, while others are wire forms stuffed and covered with sheet moss. Many metal forms are commercially available today in animal, bird, and fruit forms, but architectural forms such as giant finials, spirals, treillage, tuteur, standards, and other geometric forms are becoming popular in home decoration. Most are easily moved, amusing to decorate' for the holidays, and can be used both inside and outside the house.

We will not attempt to cover the extensive field of topiaries but rather will show you a few forms that are fun to grow and use for the holidays.

A mossed swan topiary sits on a bed of aucuba leaves between two ivy standards in small moss-covered pots. The swan and ivy standards have been decorated with gold stars to add to the Christmas spirit.

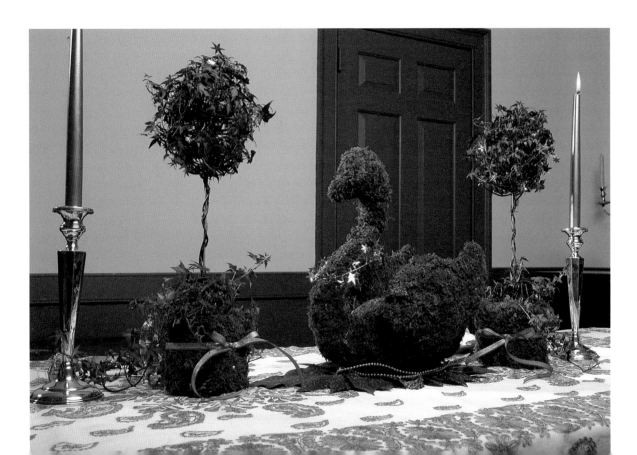

Ivy Topiary Grown in a Container: How to Plant a Standard Topiary

Supplies and materials needed: wire standard (ball-shaped) topiary form, clay pot and saucer, sterilized potting soil, soft yarn or raffia, sheet moss, and ivy with long, self-branching tendrils in a 3- to 4-inch pot (see suggested list).

A topiary grown in a container is a wonderful holiday decoration and is also a good way to begin a fascinating hobby.

Choose a plant with several long tendrils. The ivy standard pictured is made with one plant with 4 long, self-branching tendrils. The form is 18 inches tall and the pot is 5 inches wide. One tendril is pinned down in the pot to form the branching tendrils at the base.

To make this standard (ball-shaped) topiary, set the wire form into the bottom of a properly sized pot and fill half the pot with firmly packed potting soil. Remove the ivy plant from the original pot and plant it in the new pot. Add more soil and pack it firmly around the plant.

Twist the 3 longest tendrils up and around the center wire to the globe. Tie the ivy at the base of the globe with the yarn or raffia. Wrap the tendrils around the globe and weave the ends in and out to maintain the round form. Once it is well covered, pinch off the ends of the ivy to encourage thicker growth. Several short tendrils of ivy at the bottom look attractive when they are allowed to grow out over the pot. Pinch off all leaves from the center "stem" area below the globe and pinch off any large

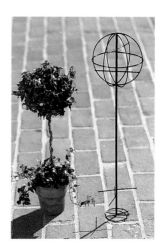

Shown here on the left is an ivy standard at full growth and beside it is a similar but larger wire form. This planted example is only 18 inches tall, and a pair make delightful table decorations.

leaves. This will encourage small leaf growth.

Holiday bows, tiny lights, small flowers in tubes, and other trims may be added. Spanish or sheet moss gives a nice finishing touch to the top of the pot. The pot may be wrapped in damp sheet moss and tied with a raffia bow. See Hints and Care (page 77).

Topiary shapes using several different plant materials are shown here.

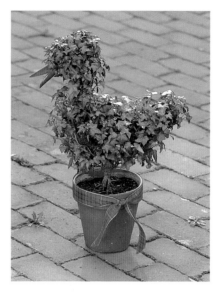

This example shows a newly started tree-shaped topiary. The ivy is planted in the pot and is woven in and out vertically toward the top. It is secured with soft yarn or raffia ties. Once the ivy reaches the top, the ends are pinched off to force thicker growth.

A moss-filled wire duck form is put into a pot and the ivy is planted in the pot and trained up and around the duck. This form has been tightly filled with soaked sphagnum moss, and as the ivy grows it is secured to the moss with fern or greening pins. When a piece of ivy becomes quite long, pinch off the ends to encourage thicker growth. A holiday bow is tied around the top of the pot.

Plants Recommended for Topiaries

The proportion of your plant materials is very important. On a small, delicate form, a tiny-leafed variety would look best. Conversely, on a large, stuffed form (see page 76) a larger leaf would be appropriate.

Plant materials recommended for topiaries: creeping fig *(Ficus pumila)*—this will root on moss forms; dwarf myrtle *(Myrtus communis)*; ivy—a favorite for the hollow topiary—including needlepoint or other small-leafed, self-branching ivies such as sagitofolia ivy with long runners, bird's foot, glacier (variegated), or cascade; rosemary *(Rosmarinus officinalis* "Arp," "Logee Blue," "Tuscan Blue," "Blue Boy"); lemon verbena *(Aloysia triphylla);* sweet bay *(Laurus nobilis);* French lavender *(Lavandula dentata);* silver thyme *(Thymus argenteus);* santolina *(Santolina Chamaecyparissus);* English ivy *(Hedera Helix)*—which is especially good for large forms.

Ivy Topiary Grown in a Moss-Filled Wire Frame

Supplies and materials needed: wire topiary form with flat bottom, long-fiber sphagnum moss, sheet moss, nylon fishing line—10 pound test, apple corer or knife, #24 gauge green floral wire, tiny hairpins, fern pins, or greening pins, clippers, and rooted plants in 3-inch pots (see page 75) with long, self-branching tendrils.

Free-standing topiaries, or what the noted garden authority Rosemary Verey calls "portable leafy sculptures," require more care than the example just given which is grown in a pot. However, they can be amusing and marvelous forms and well worth the effort.

To create this portable topiary, the ivy is planted in the stuffed and moss-wrapped wire topiary frame and it is pruned and trained to cover the outside of the mossed frame.

Soak long-fiber sphagnum moss until it is thoroughly wet. Squeeze out most of the water. Pack this into the center of the form until it is tightly filled. Cover the outside with sheet moss secured with fishing line. When totally packed and covered with sheet moss, cut holes into the main areas with an apple corer or knife and gently insert small rooted plants or cuttings with long runners and a little soil around the roots. Press the moss mixture around the roots to prevent air pockets and, if needed, add a small amount of moss at the surface to secure the plant. When the main areas of the form are planted, trail the runners over the form and anchor them with pins.

As the plants grow, keep pinning them to the moss. Pinch off large leaves to force more and smaller growth. When the form is well covered, pinch off new ends to encourage thicker growth. See Hints and Care (page 77).

Mist the surface frequently and keep the form damp at all times as this type of topiary will dry out quickly. The bunny's ears in this example will need to be kept damp to grow properly. If you want to use this type of form on a table, place the topiary on a dish filled with pebbles and water. The topiary will like the humidity and will be raised above the water. The furniture will be protected.

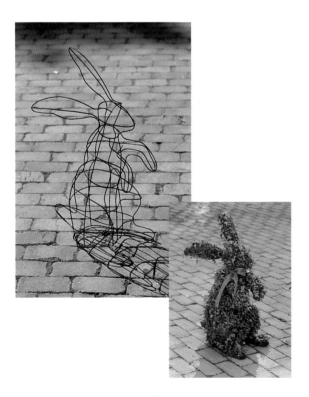

This large metal form is filled with moss and covered with sheet moss. Large English ivy is planted in the form and trained over the surface.

Hints and Care

Watering:

> Keep soil or moss moist, not wet.
> Mist the leaves frequently.
> Thoroughly soak planted topiaries growing in mossed forms on a regular basis.
> Keep the small or narrow areas of mossed frames damp.

Light:

> Bright light at least two hours a day. Never leave in hot/direct sun.
> Turn frequently to keep growth even.
> Good air circulation is important.

Feeding:

> Add tiny amounts of 10–15–10 fertilizer each time you water except during winter.
> Water occasionally with 24–14–14 for leaf and root growth.
> Water with fish emulsion two times a year.
> Mist with a dormant oil spray once a month to prevent spider mites and aphids
> and to give the leaves a bright, glossy look.

Temperature:

> Thrives outside and will tolerate temperatures to 30° F.

Pruning and Training:

> Pinch off all large leaves to force small growth.
> Cut out areas where growth is sparse and train new tendrils
> to grow over these areas.
> Secure tendrils to the frame with pieces of soft yarn, raffia, or fern pins.
> Trim ties close to the frame.

Pots/Planting:

> Use clean clay pots to provide needed weight.
> As the plant grows, do not change the size of the pot. Take the plant out of the pot
> periodically, trim the roots, make a few vertical cuts into the root area, shake off soil,
> and replant the topiary in fresh soil in the same pot, washed. Pack well and water
> thoroughly.
> Use sterilized potting soil in clay pots and long-fiber sphagnum moss for stuffing
> topiary forms.
> Be sure to use correct size pots—not too large—ones that will balance the whole design.

How to Make a "Faux" Topiary

Supplies and materials needed: ornamental pot, plastic liner, approximately 5½-foot-long branch or sapling, 6-inch piece of small wooden dowel or long nail, electric drill with a bit the size of the nail or dowel, ready-to-mix cement, water, gravel, 1 block wet floral foam, chicken wire or garden netting, ice pick or other sharp implement, #16 gauge green floral wire, long unwired wooden floral picks, conditioned greens (see page 136), accessories (here gilded pears and partridge), and Spanish moss or sheet moss.

This basic technique is extremely versatile. Although it can be made any time of the year using fresh or dried flowers, we concentrate on a form that is especially delightful to do for the holidays.

A "faux" topiary may be made in any size from the large 6-foot example detailed here to small sizes for a dining table or even tiny ones for place favors at a table. The process is similar for all.

Select an appropriate size pot for the topiary. If it is a pot you will use for other projects, find a plastic pot or liner that will fit snugly inside it. Cut a straight branch, or small tree trunk if making a large form, approximately 6 inches shorter than the total height you wish to make the topiary (see the drawing). Make a slight point at the top of the trunk and drill a hole through it approximately 2½ inches from the top. Insert a 6-inch piece of wooden dowel or a long nail as shown.

A "faux" topiary at the Williamsburg Inn is one of a large pair made with Alexandrian laurel, boxwood, and gilded pears and a partridge.

Set the branch into the liner. If you use a plastic pot with drainage holes, be sure to tape the holes. Mix the cement in a separate container and pour it into the liner at least one-half the depth of the pot as shown. Be certain that the trunk is perfectly vertical. Allow the cement to set overnight or until dry.

NOTE: Cement is best to use in a large topiary; plaster of paris in a small one. You will need sufficient weight at the bottom to balance the top of a large form.

When the cement is thoroughly dry, put the plastic liner with the cemented branch into the outer pot and fill the remaining space at the top of the liner with gravel as shown. If there is space between the liner and the ornamental container, fill the gap with mulch or other material to keep the topiary straight. Impale the wet floral foam on the trunk so that it rests on the dowel as shown. Wrap the floral foam with chicken wire or garden netting. Remove the leaves from the bottom 2 inches of the stems of 6- to 8-inch sprigs of boxwood. Fill in the floral foam with conditioned greens as shown so that a round shape is made. The pieces of boxwood are used to create the basic round shape. Longer pieces of Alexandrian laurel give depth and an airy, graceful look.

The accessories here are gilded pears and a partridge that have had holes made with an ice

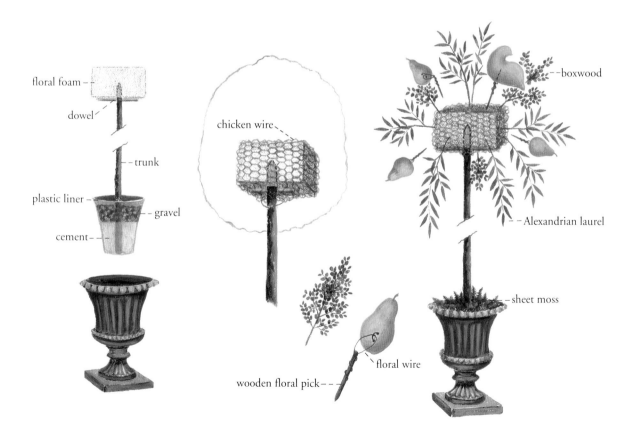

pick on the back and have been wired with floral wire as shown. This wire is wrapped around long wooden floral picks, which are inserted into the foam. The top of the liner may be covered with Spanish moss or sheet moss.

NOTE: A permanent "faux" topiary may be made using dried materials in dry floral foam. Dried flowers, herbs, leaves, and small berries used in this same large form or in a small form would be lovely. A fresh herb topiary is a Williamsburg favorite. When made it is packed tightly so that when it dries the form is solidly filled and becomes an attractive permanent topiary that retains its wonderful scent. Rosemary is a favorite herb to use as a filler. Consider using trunks with unusual bark or forked shapes to add interest.

Mossed Topiaries

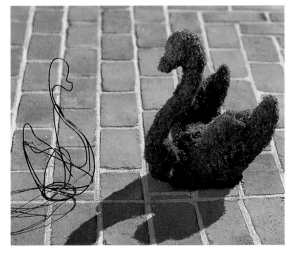

A mossed swan topiary sits beside a smaller unstuffed wire form.

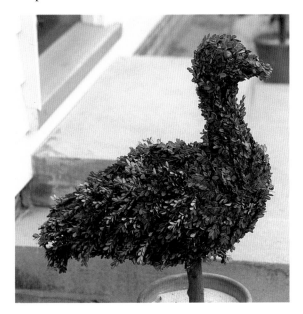

This boxwood "faux" topiary goose with a cranberry eye is made in a wire form stuffed with moss, which is then filled with boxwood sprigs and placed in a clay pot to simulate a growing form.

Mossed topiaries are pleasing additions and once made will last for many years. Any wire form for topiaries may be used or you can make your own form. Long-fiber sphagnum moss is soaked and used to stuff the topiary. Sheet moss, which is available in large pieces, is used to wrap the outside to conceal the frame. The sheet moss is secured with fishing line or fern pins. The topiary may be used dry or damp, hung from the wall, or used on a table. Fresh decorations such as a floral necklace for the swan or perhaps a bow for the fox may be added.

Opposite: At Carter's Grove a hunting theme inspired these mossed fox heads with Christmas red bows hung along the walls in the Morning Room. The festive red is echoed in the red poinsettias, red fabric, stuffed fox figures dressed in holiday red, and a horse topiary with a red leather harness.

How to Make a Kissing Ball

Supplies and materials needed: ½ block soaked floral foam, chicken wire or garden netting, twine, #18 gauge green floral wire, clippers, 4-inch sprigs of conditioned boxwood (see page 136), and ribbon.

Kissing balls are popular in Williamsburg at Christmas and can be decorated in a variety of ways and used indoors or out. The example shown on the opposite page is a basic boxwood kissing ball that has been decorated with cranberry and green grape chains.

Wrap ½ block of soaked floral foam with chicken wire or garden netting as shown. The overlap, when using chicken wire, may be secured with #18 gauge floral wire or the garden netting may be tied together at the top and bottom with twine and the ends trimmed. Insert a 10-inch piece of floral wire through the center of the floral foam and make a hook shape at the bottom. Pull the wire up from the top so that the wire hook is pulled up and becomes embedded in the floral foam and wire or netting. Make a loop in the wire at the top and use this to attach the ribbon or your hanger as shown.

Remove the leaves from the bottom inch of the stems of 4-inch sprigs of boxwood. Insert the stems into the floral foam to form a solid, well-filled, round form as shown. Any especially ragged ends may be trimmed, but a certain amount of unevenness is pleasing.

To create the decoration on the kissing ball shown here, string cranberries and grapes on strong thread and secure the ends with wire in

A mossed kissing ball is decorated for a children's party. Interlocking embroidery hoops are wired in place, then wrapped with dampened sheet moss that is secured with thread or fishing line. Mistletoe or any other small decoration may be hung inside or from the bottom and ribbon may be added. It is easier to work with dampened sheet moss because it is more pliable. Any size hoops may be used, fresh materials may be added for a special event, or the entire frame may be wrapped with boxwood in the same manner as shown on page 8 to make a wreath.

the floral foam at the top and bottom of the kissing ball. Attach a piece of wire to a bow and insert it into the top. Attach a second piece of wire to ribbon streamers and insert it into the bottom of the floral foam.

NOTE: Kissing balls using fresh or dried herbs, flowers, cones, berries, or fresh greens make wonderful holiday decorations. If using fresh materials that will be allowed to dry to create a permanent form, be sure to fill the form very tightly so that the floral foam will not show as the materials dry.

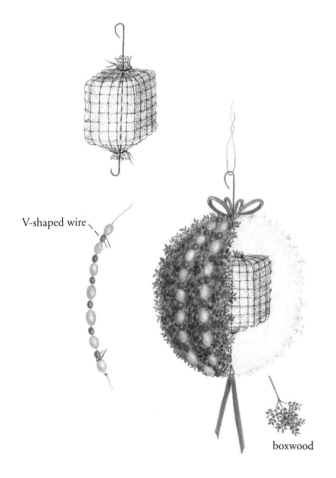

V-shaped wire

boxwood

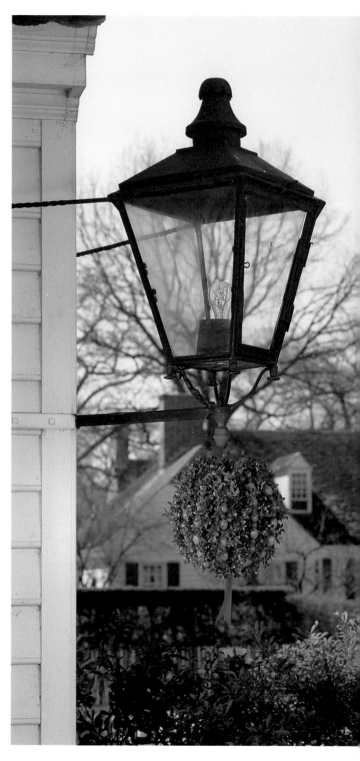

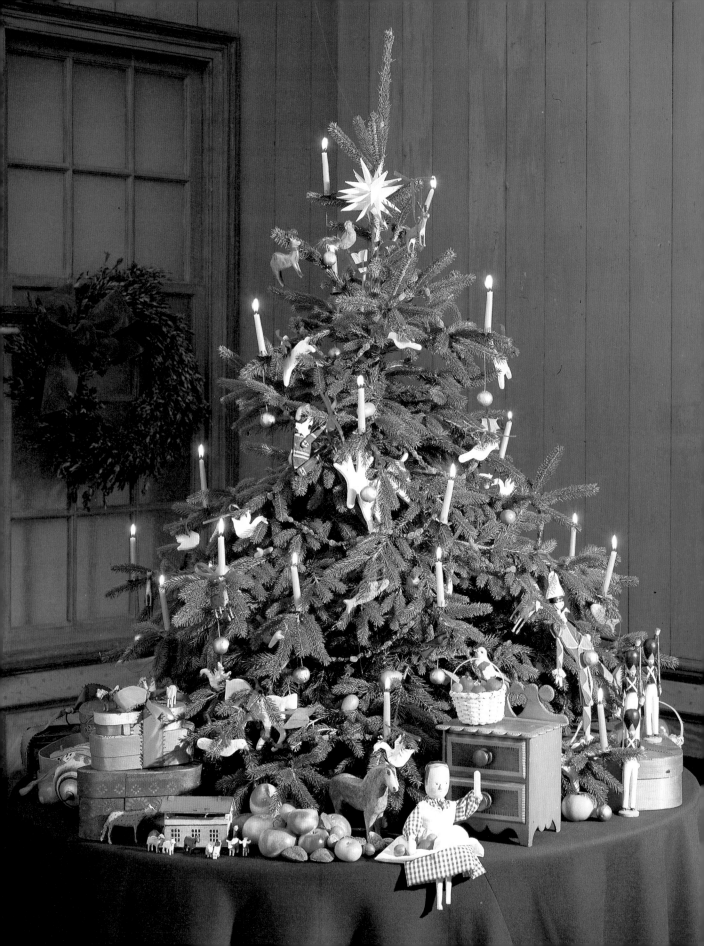

Christmas Trees

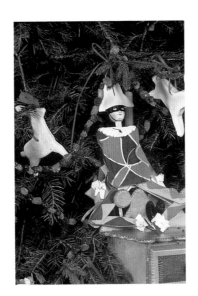

Opposite: The Moravian star crowns this tabletop tree, and a stick toy, a raisin chain, cookies, and beeswax candles show how the earliest trees were decorated.

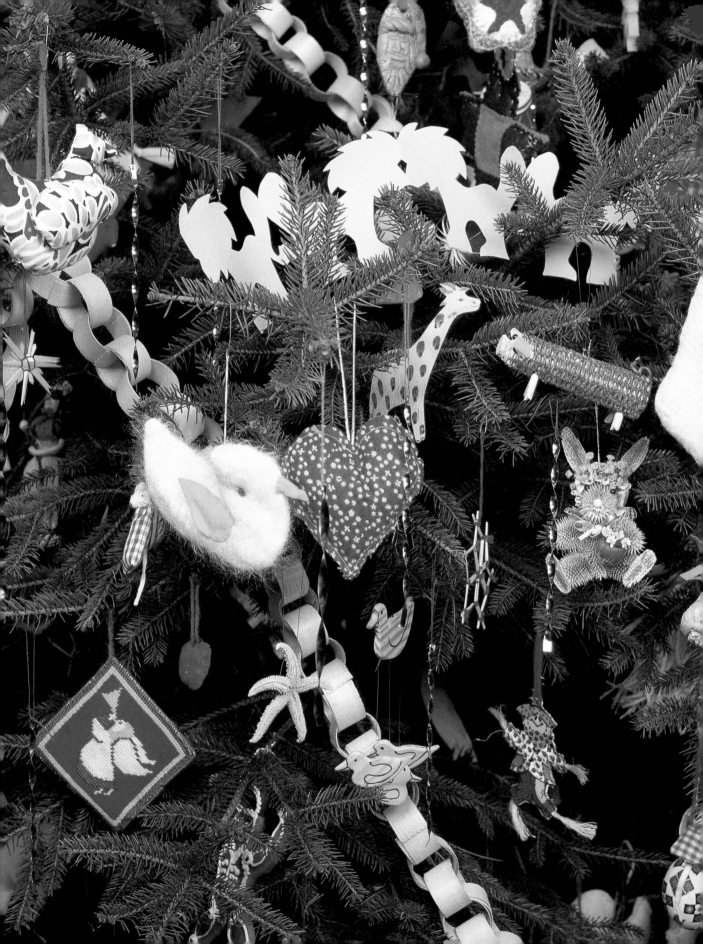

A DISCUSSION OF HOLIDAY DECORATIONS in Williamsburg is not complete without talking about some of the special trees, although none are seen in exhibit buildings that interpret the eighteenth century. The German tradition of using a live tree trimmed with special ornaments came to Williamsburg in 1842 when a professor at the College of William and Mary, Charles Minnegerode, presented a small tree to the children of his friend Professor Nathaniel Beverley Tucker.

Today, we have a wide variety of trees in Williamsburg. The small tabletop tree at the Abby Aldrich Rockefeller Folk Art Center, which is trimmed with old toys, gilded nuts, counterweighted beeswax candles, and sugar cookies, is far different from the large formal blue spruce Regency tree at the Williamsburg Inn, primarily decorated with gold and crystal ornaments, or from the gigantic Christmas tree at Carter's Grove, whose branches are laden with colored balls so popular in the 1930s.

A number of other trees are decorated each year for our guests' enjoyment during a Christmas visit to Williamsburg.

Above and opposite: Close-up views of the Folk Art Center's tree show the variety of ornaments used to trim it. Frosted gingerbread boys, the chain of wood shavings, various needlework decorations, delightful little teasel and corncob ornaments, and carved wooden figures represent a wide range of traditional crafts.

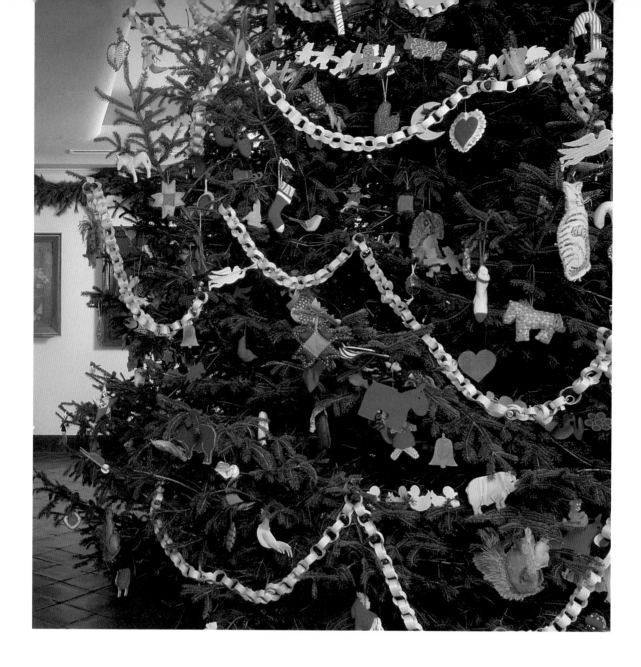

KNOWN AS THE FOLK ART TREE, this huge tree at the Abby Aldrich Rockefeller Folk Art Center is probably the most familiar to our visitors. Trimmed from top to bottom with handcrafted ornaments based on folk traditions and enchantingly decorated gingerbread boy cookies, it is visually unified by the chain of wood shavings made for the tree by the coopers in the Taliaferro-Cole Shop in the Historic Area. Some of the traditional crafts represented are quilling, wheat weaving, several forms of needlework, carving, and ornaments made with shells, corncobs, teasels, nuts, and numerous other natural materials.

Carved and false grain-painted angel ornaments are reminiscent of a nineteenth-century weather vane from the collection.

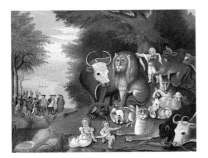

A needlework ornament is based on the Peaceable Kingdom paintings by Edward Hicks, one of America's most celebrated folk painters of the nineteenth century. "The wolf also shall dwell with the lamb" is embroidered around the edge.

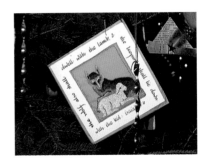

The watercolor and ink drawing on the left dating from about 1780 represents George and Martha Washington. On the right are two needlepoint ornaments worked on canvas.

A "penny-rug" is a design source for these charming embroidered rounds. Coins were frequently used as templates and different sizes were superimposed one above the other and joined with a variety of embroidery stitches.

A nineteenth-century double-woven coverlet inspired this group of needlepoint ornaments. The colors duplicate those used in the original textile. An old quilt might suggest a design for an ornament.

A VISIT TO THE DOLLHOUSE at the Folk Art Center is the favorite objective of many a child and grandmother. The house is a collection of different-sized box "rooms" under one roof that, when assembled, present a complete house to be explored in detail. The house is filled with a variety of interesting furnishings, and in the parlor a tree is covered with ornaments that duplicate many of the ones found on the large tree.

Below: The parlor of the dollhouse is decorated for Christmas with tiny wreaths in the windows, garlands over the doorway, stockings hung on the fireplace, and a tree surrounded by packages and toys.

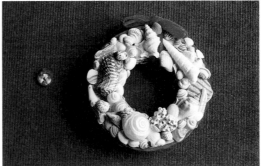

Left: Here are Henny Penny chicken from the large tree and its miniature from the dollhouse tree. Both have guinea hen feather tails and cloth bandannas. *Right:* The large shell wreath from the big tree dwarfs the one made with minute shells for the dollhouse.

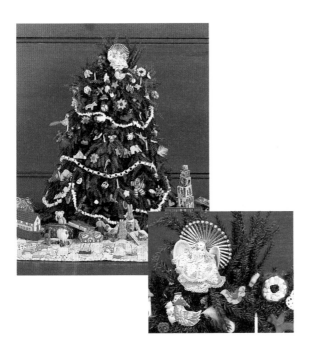

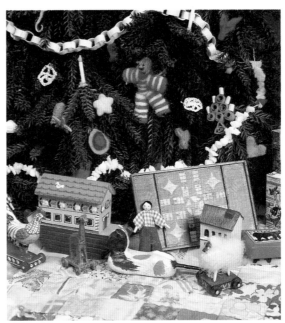

In the detail of the top of the tree above, the shell-winged angel is surrounded by a quilled paper tree, a shell wreath of tiny shells, Henny Penny chicken, a woven star, fabric birds, a crocheted circle, and other miniature ornaments similar to those on the big tree.

Toys assembled at the base of the tree are miniatures of toys in the Folk Art Center and are a part of Colonial Williamsburg's reproductions program.

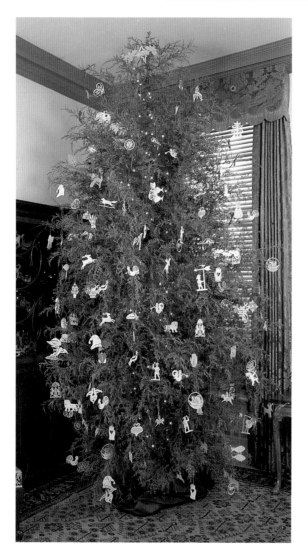

scherenschnitte, or cut-paper ornaments, tied with red strings. The designs of the ornaments are based on objects and textiles from the Abby Aldrich Rockefeller Folk Art Center. Red picot ribbon bows add interest and color. The tree is illuminated from within by tiny white lights.

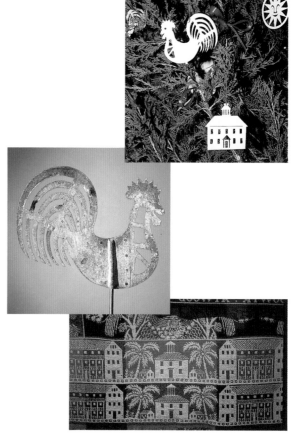

GUESTS AT THE LIGHTFOOT HOUSE are greeted by this bushy fourteen-foot cedar tree. Its narrow, columnar shape emphasizes the formality of this high-ceilinged room that is filled with antique furnishings and elegant fabrics. In keeping with the formal feeling of this house, and the wish to use a cedar tree whose fragile branches would not support much weight, the colors were limited and the tree is trimmed with delicate parchment paper

Two scherenschnitte ornaments are seen above the objects that inspired them. The mid-nineteenth-century sheet copper rooster weather vane with its exaggerated curved tail and open geometric design is an outstanding example of both craftsmanship and design. A nineteenth-century coverlet contains a repetitive border design of a building similar to the one hanging on the tree.

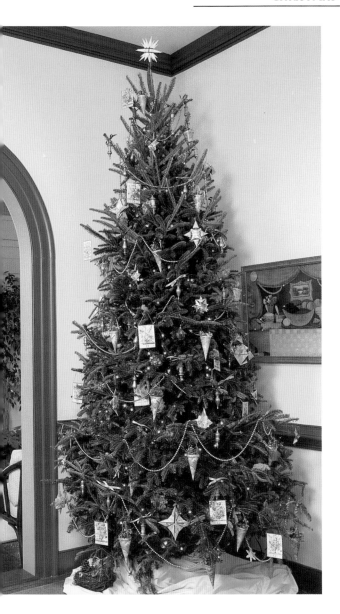

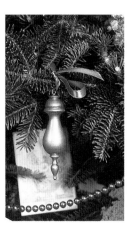

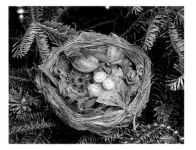
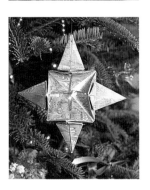
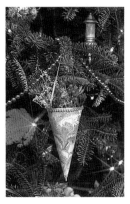

VISITORS TO PROVIDENCE HALL HOUSE, a guest facility on the edge of the woods, will see handmade ornaments based on the colors of this colonial home's furnishings. The tree decorations include soft blue marbleized paper stars and cornucopias filled with boxwood, rose hips, and baby's breath; specially turned wooden spindles, gilded and tied with soft blue and gold ribbons; dried flower nosegays; gold-edged floral prints; small nests filled with potpourri, eggs, and birds; white ceramic stars; bundles of cinnamon sticks; and yarrow. A large nest filled with potpourri sits at the base of the fraser fir tree.

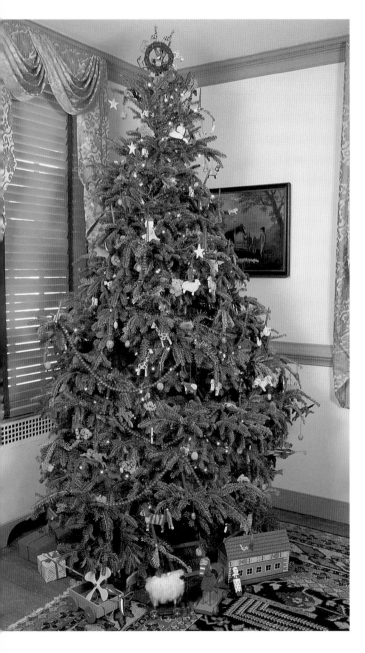

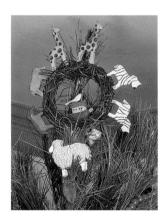

A grapevine wreath with pairs of small animals and a Noah's Ark decorates the top of the tree.

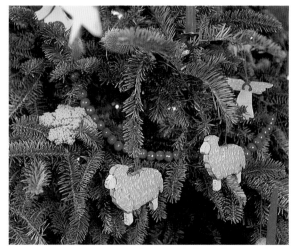

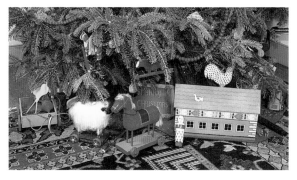

THIS NOAH'S ARK TREE at the Moody House is decorated with pairs of animals, nuts, teasels, and golden sleigh bells tied with red string. Tiny white lights, red candles, a wooden "cranberry" chain, and pieces of yarrow brighten the tree. Colonial Williamsburg reproduction toys and a Noah's Ark made by the author surround the base.

A TREE DECORATED WITH NATURAL MATERIALS, located in a small guesthouse, was designed to be compatible with the bold blue and white check and the other strong blue textiles present. The tree is decorated with corn dollies, false grain-painted wooden shapes, gingham bags filled with fragrant cloves, and onion-skin-dyed eggs with herb designs hung from the tree in linen holders. Straw goats stand guard beneath the tree.

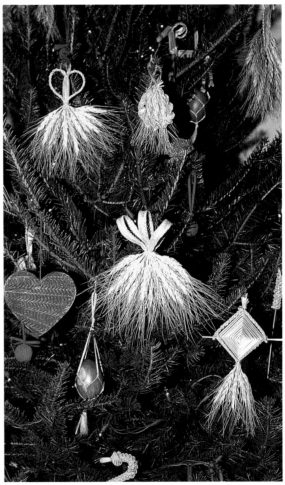

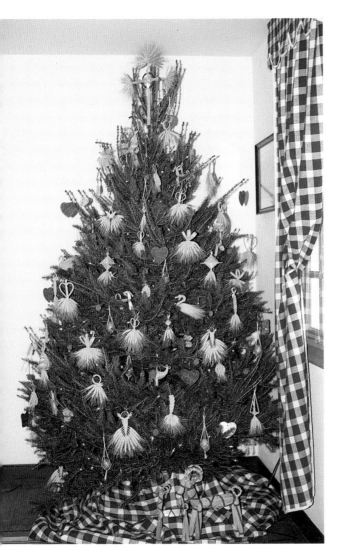

The corn dollies, or woven wheat ornaments, represent a number of traditional designs. The large cross on the tree top is woven with three varieties of wheat.

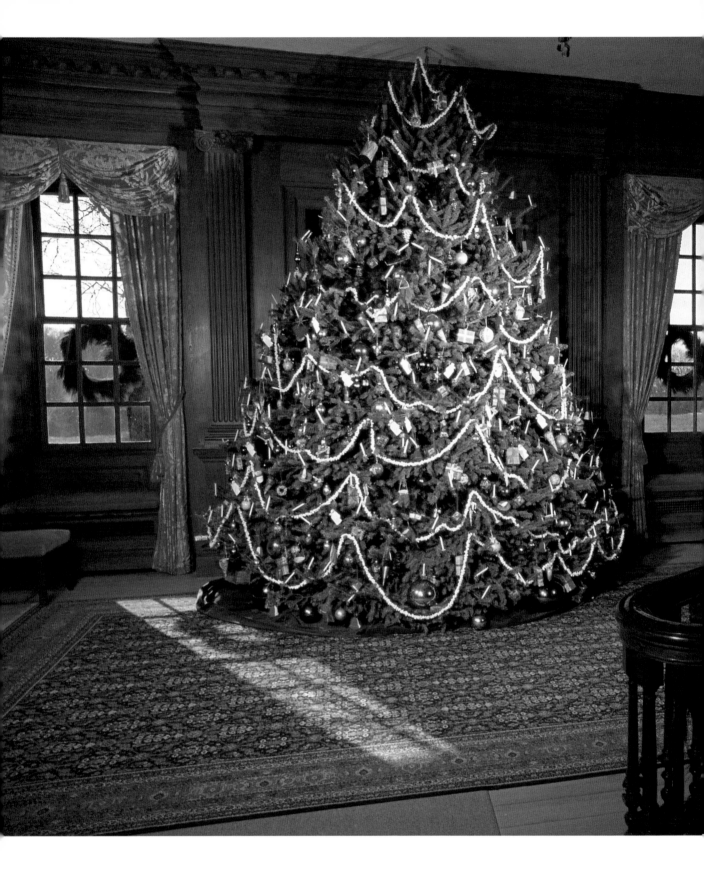

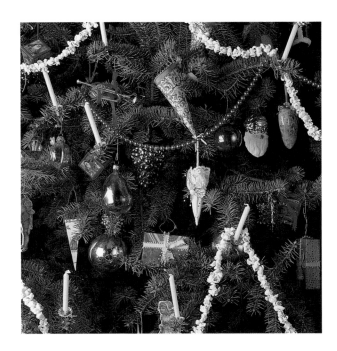

THE GREAT HALL at Carter's Grove, dominated at Christmastime by this gigantic tree, is noted for its magnificently crafted wood paneling and broad staircase with a handsome curved banister. Through the windows flanking the wide doorway, visitors are treated to a sweeping view of the James River.

The ornaments on this tremendous spruce tree have been collected over the years and probably represent the type of holiday trimmings used by many Carter's Grove families. Large nineteenth-century silvered kugels rest on the floor, and smaller examples of these hand-blown thick-walled glass balls are scattered over the tree. Paper cornucopias, small packages tied with festive ribbons, and small Victorian lace parasols and fans are intermixed with popcorn and shiny bead chains.

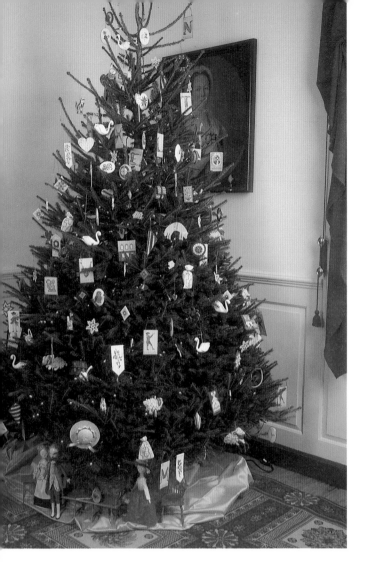

AT THE DR. BARRAUD HOUSE hand-stitched needlework ornaments based on designs from Colonial Williamsburg's textile collection, toys from the shops in the Historic Area, handmade toys, and painted ovals decorate this lovely tree. The cranberry red fabric used in this room is a dominant color on the tree.

Fabrics, ceramics, and wallpaper in the house and in the DeWitt Wallace Decorative Arts Gallery inspired many of the ornaments. Colorful designs are worked in crewel, canvas work, bargello, tatting, or other embroidery stitches. Needlework and wooden tavern signs, crocheted lambs and swans, a tiny sampler, tatted stars, sachets made with old lace, hand-painted wooden scenes, and small toys are but a few of the special ornaments that were designed for this tree.

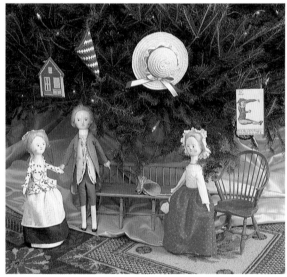

Furniture and dolls dressed in colors from the room, all from Williamsburg's reproductions program, are arranged beneath the tree.

An exhibit at the DeWitt Wallace Gallery included the original Hagar Tyler doll. The oval needlework design on the right is based on the design in the doll's dress. The modern Hagar is seen on the right.

The design for the needlework oval is based on the small eighteenth-century needle case shown above on the left that is believed to be one of a pair made by sisters.

Assembled here is a selection of the ornaments that have been used on this tree: a ribbon-edged letter from an alphabet game, a needlepoint representation of a Colonial Williamsburg building, a ceramic bird whistle, a small wooden drum, a painted oval of an apple cone, a tiny bargello replica of a man's purse, and a quillwork paper tree.

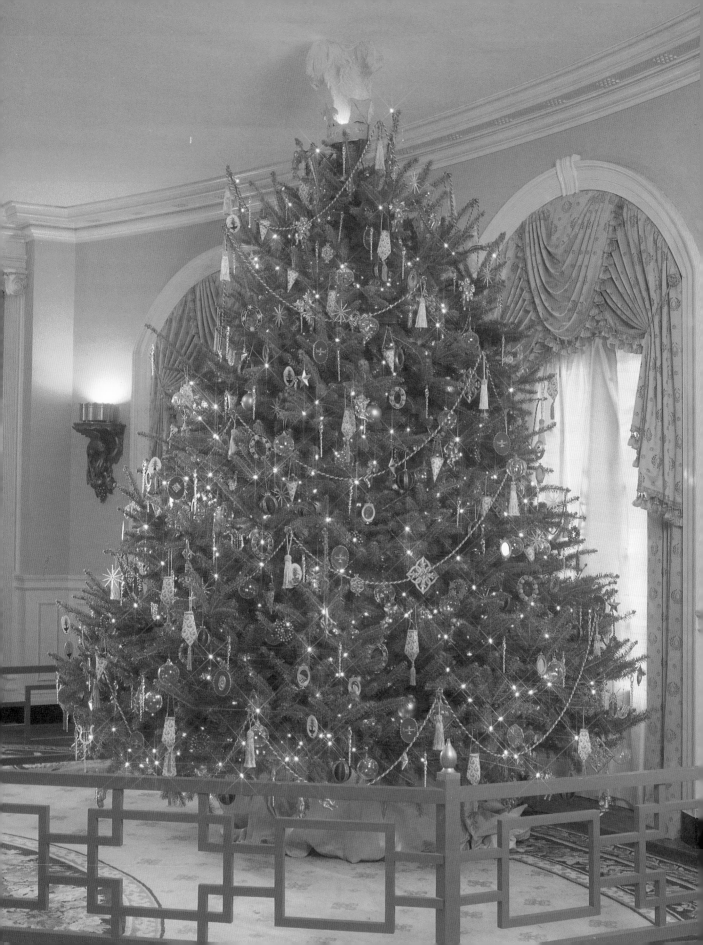

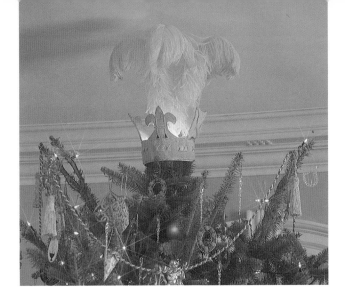

THE REGENCY TREE was designed to reflect the elegance of the furnishings and architectural details at the Williamsburg Inn. It is trimmed with handcrafted ornaments, made especially for this tree, that recall elements of the Regency period. Highlighted by the striking Prince of Wales crown of needlework and ostrich plumes at the top of the tree, it celebrates one of the great art patrons of this period, George IV of England, the former Prince of Wales. Tassels and swags, delicate gilded mirrors and medallions, stars, lyres, urns, cherubs, fleurs-de-lis—all are characteristic of this period. Ladies' reticules are made with Colonial Williamsburg's "Brighton" dollhouse wallpaper, as are cornucopias filled with tiny gilded hemlock cones. Wreaths of dried flowers echo the design in the center of the rug in front of the tree. All of these ornaments are carefully placed on the tree to reflect the tiny white lights and to hang freely to ensure movement.

A soft gold leaf color was used to gild each painted ornament. This same color of gold was used for the ribbon, cording, tassels, and the threads used for making the crown. The only other colors on the tree are cranberry red, soft sage green, and cream.

Roping is arranged in swags around the tree and a gold tassel hangs at the top of each swag where it is caught over a branch. The fence shows the influence from the Chinese Chippendale designs at Brighton Pavilion.

A close-up view above of the top of the tree shows the needlework crown and ostrich plumes. The wooden carving that inspired this skillfully worked crown is shown on the right.

101

Three versions of an oval wreath of dried flowers recall the oval from the large rug in front of the tree. The same colors that are found in this oval in the rug are used in the ornament.

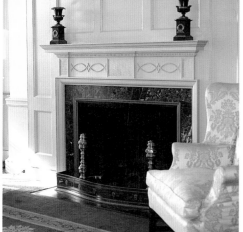

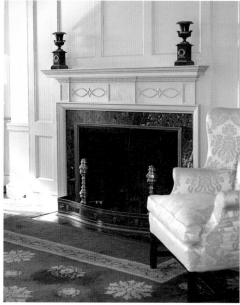

The East Lounge at the Williamsburg Inn illustrates the many influences and design sources that inspired ornaments found on the tree. The wreath design on the pair of urns on the mantel, medallions in the rug, classical motifs in the fireplace surround, and patterns in the upholstery used on the wing chair are all translated into ornaments for the tree.

Opposite: A detail from the Regency tree gives a close-up view of some of these lovely ornaments. Hand-painted urns on wooden medallions, ovals of dried flowers, hand-blown melon-shaped crystal balls, gilded and mirrored architectural shapes, and twisted icicles reflect the light and contribute to the elegance of this formal tree.

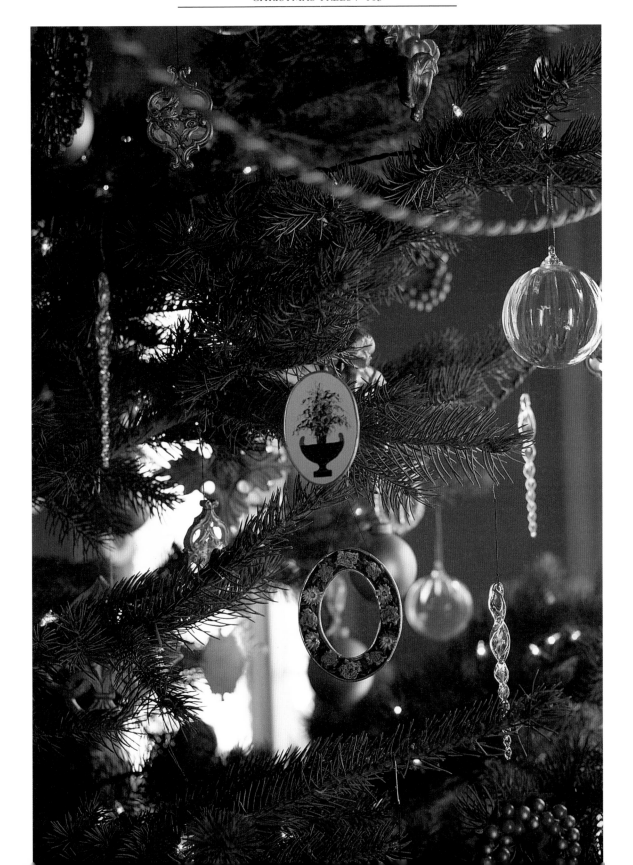

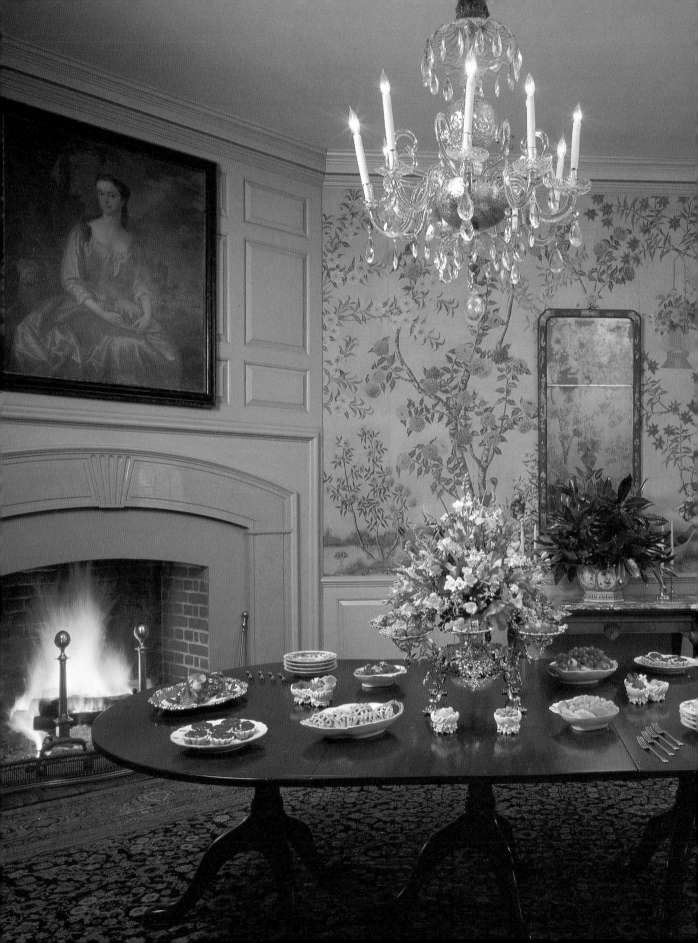

Holiday Tables

The elegant dining room table at the Lightfoot House is prepared for a dessert open house. The setting is highlighted by the magnificent silver epergne made in London in 1759 by William Cripps. The glorious flowers echo the colors in the hand-painted Chinese wallpaper. Desserts are served beside a cheerful fire on Colonial Williamsburg's Chelsea bird porcelain plates.

THE CHRISTMAS HOLIDAYS provide a marvelous reason for entertaining and an occasion to try new recipes. Perhaps you will host a buffet following caroling that features hearty foods like those served in a colonial tavern, or a whimsical child's party, or a formal open house. Many ideas for both formal and informal holiday table decorations are given in the following pages as well as a selection of tasty recipes.

The dining room at the Lightfoot House *(overleaf)* is a handsome setting for a selection of tempting desserts. The antique English silver epergne is filled with a brilliant arrangement of flowers. The greens provide a perfect foil for bright parrot tulips; intense blue Dutch iris; yellow and white freesias; white bouvardia, lilacs, larkspur, and narcissi; red tulips; and yellow Carolina jessamine. The companion pieces contain flowers and sugared violets, pineapple mint leaves, and scented geranium leaves.

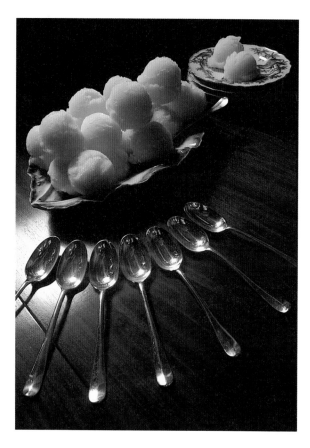

CHAMPAGNE SHERBET *1½ quarts*

2 cups sugar
2 cups water
⅔ cup corn syrup
juice of 2 lemons
1 drop yellow food coloring
1 bottle champagne
3 egg whites, unbeaten and divided

Bring the sugar and water to a boil. Add the corn syrup, lemon juice, and food coloring. Cool. Pour the mixture into a large shallow pan, cover, and freeze. When the mixture is frozen, remove it from the refrigerator and let it stand at room temperature for a few minutes. Scrape the mixture into the bowl of a food processor or blender. Mix until smooth. Add the champagne. Return the mixture to the freezer until frozen. Remove and let stand a few minutes. Place ⅓ of the mixture in the bowl of a food processor or blender. Add 1 unbeaten egg white. Mix until smooth and place in a container. Mix the second ⅓ of the sherbet with 1 unbeaten egg white as above. Repeat with the remaining mixture and egg white. Cover and freeze.

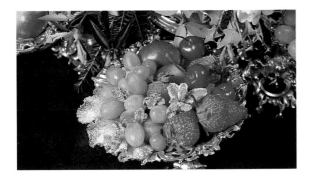

HOW TO SUGAR FRUITS, FLOWERS, AND LEAVES

Place a cake rack over waxed paper. Using a small watercolor brush (#2), paint the fruit, flower, or leaf you wish to sugar with the slightly beaten white of an egg. Place it on the rack and sift fine granulated sugar over it. If an area is not well covered with sugar, add some egg white to that area with the brush and sift more sugar over it. Leave the sugared material on the rack to allow the coating to harden. This process can also be done with fresh flowers and leaves such as violets, scented geranium leaves, or mint leaves as used here.

MINCEMEAT *4 quarts*

1½ pounds beef, top round
1 tablespoon butter
½ pound beef suet, finely chopped
8 cups tart apples, cored, peeled, and chopped
½ pound citron, finely cut
½ pound candied lemon peel, finely cut
1 pound raisins
1 pound currants
2½ cups dark brown sugar, packed
3 cups cider
½ teaspoon salt

1 tablespoon cinnamon
½ tablespoon nutmeg
½ tablespoon ground cloves
½ tablespoon allspice
½ tablespoon mace
1 cup walnuts, coarsely chopped
1 tablespoon lemon juice
brandy

Brown the beef in the butter. Cover it with water and simmer in a heavy saucepan until the meat can be shredded with a fork—approximately 3½ to 4 hours. Mince the meat with a knife and mix it with the suet, apples, citron, lemon peel, raisins, currants, brown sugar, cider, salt, cinnamon, nutmeg, cloves, allspice, and mace in a large, heavy kettle. Bring to a boil, lower the heat, and simmer, uncovered, stirring frequently, about 2 hours. Remove from the heat. Add the walnuts, the lemon juice, and ½ cup of brandy. Place in a covered crock and age for at least 3 weeks, adding brandy as needed and stirring periodically.

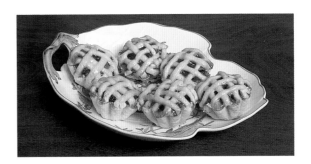

MINCEMEAT TARTS

Fill tart shells with mincemeat, top them with crisscross lattice pastry strips, and bake for 20 minutes at 350° F. or until the pastry is golden brown.

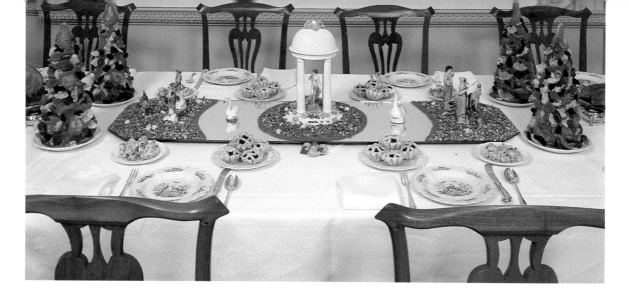

IN THE GOVERNOR'S PALACE SUP-PER ROOM, the table is set for a seated late ball supper. A symmetrical display on the dining table was a requirement for a successful party in the eighteenth century. Hannah Glasse, an eighteenth-century English cookbook author whose works were required reading in any fashionable household, spoke of the importance of the symmetry of dishes and gave the following description of the centerpiece: "The above middle frame . . . on which suppose gravel walks, hedges, and variety of different things, as a little Chinese temple for the middle, or any other pretty ornament . . . the top, bottom, and sides are to be set out with such things as are to be got, or the season of the year will allow, as fruits, nuts of all kinds, creams, jellies, whip syllabubs, biscuits, &c. &c."

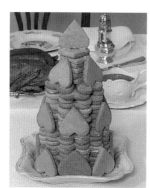

Balancing pairs of pyramids of sugar cakes and ginger cakes were a popular way to arrange small cakes or "cookies" for the table. Frosting can be used to hold these cookie pyramids together.

The mirrored imitation pond shown above is surrounded with areas of colorful stones on which porcelain figures walk and animals graze. Red coral chips form a border around a goddess in her temple, swans swim nearby, and plates of mincemeat tarts and pairs of dried fruit cones surround the centerpiece.

RICH CAKE

3 cups butter
1½ cups granulated sugar
½ cup light brown sugar, packed
1⅓ cups almonds, blanched
½ cup sherry, divided
6 large egg yolks
3 large egg whites
¼ cup brandy
1 teaspoon mace
1 teaspoon cloves
1 teaspoon cinnamon
¾ teaspoon freshly ground nutmeg
dash of ginger
4 cups sifted cake flour
1¾ pounds currants
¼ cup candied orange peel, finely cut
¼ cup candied lemon peel, finely cut
¼ cup citron, finely cut

Preheat the oven to 400° F. Grease well and

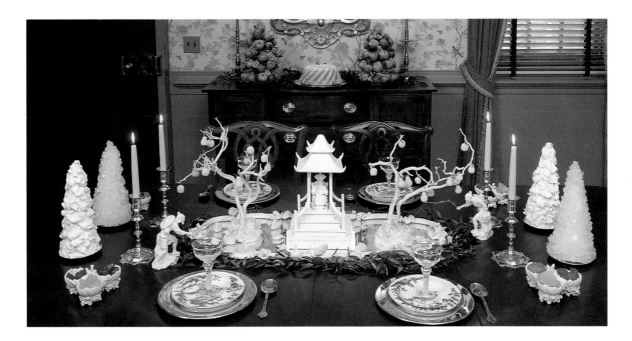

lightly flour a 12-cup and a 6-cup bundt pan. To achieve the texture of the original cake, work the butter with your hands until it resembles thick cream. Gradually add the sugars, and using your hands or a wooden spoon continue until the butter loses its gritty texture. Process the almonds in a food processor with ¼ cup of sherry until the mixture forms a paste. Add to the creamed mixture. Beat the egg yolks and whites together and then slowly add to the mixture. Add the remaining sherry, brandy, and spices. Mix well. Gradually add the sifted flour. When the batter is well blended, add the currants and candied fruits. Spoon into the prepared pans. Place a pan of hot water on the bottom shelf of the oven to help prevent dryness. Place the cakes on the middle rack, reduce the heat to 325° F., and bake for approximately 45 minutes for the small cake and 60 minutes for the large cake or until a cake tester comes out clean. Cool for 20 minutes and remove from the pans. Keep the cakes well moistened with cheesecloth soaked with sherry or brandy.

AT CRAFT HOUSE a splendid adaptation of the formal and symmetrical table of the colonial period is pictured. Balancing pairs of sugar and whipped cream cones surround a temple on a mirrored surface that is ringed with a wreath of Alexandrian laurel. Reproduction Chelsea shell sweetmeat dishes are filled with dried fruits and marzipan. Sugared branches hung with marzipan pears spring from islands of rock sugar crystals, and marzipan swans float on a glistening lake. The Chelsea porcelain plates with exotic bird designs are also reproduced by Colonial Williamsburg from those made in the mid-eighteenth century.

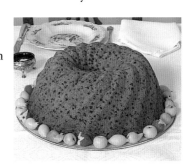

Rich cake, a favorite with colonial Virginians, is shown here on the Governor's Palace supper room table. Above, a sugared version is on the sideboard. The recipe has been adapted for modern use.

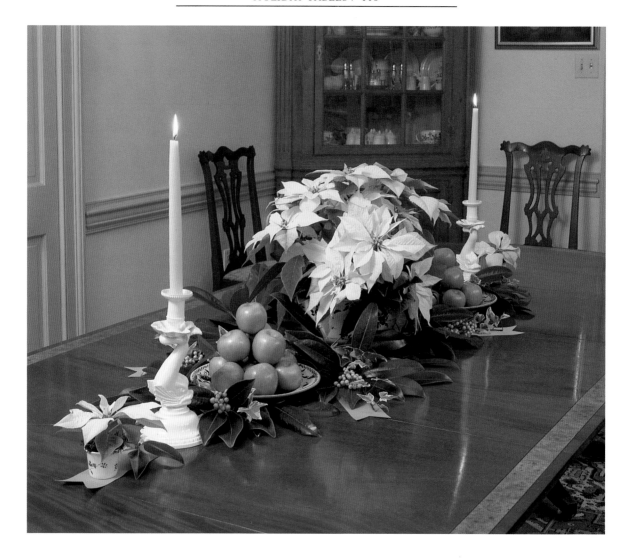

White poinsettias and green apples in delft pottery and accents of white nandina berries, magnolia leaves, and variegated ivy on blue ribbons make a bold statement.

AN UNUSUAL COMBINATION of flowers, fruits, and berries forms a line down the center of this table, with its focal point of white poinsettias massed in a delft punch bowl. Water-filled delft inkwells contain conditioned white poinsettia blooms (see page 136). A pair of white saltglaze candlesticks in the shape of dolphins is placed on the blue ribbon next to a delft plate holding a pyramid of Granny Smith apples. The poinsettias were unpotted, some of the dirt was removed, and they were set into plastic bags. The plants were then arranged in the bowl. Many plants, too tall to use in their pots, may be used in this way. White nandina berries, variegated ivy, and magnolia leaves are placed on the crossed blue ribbons in the center.

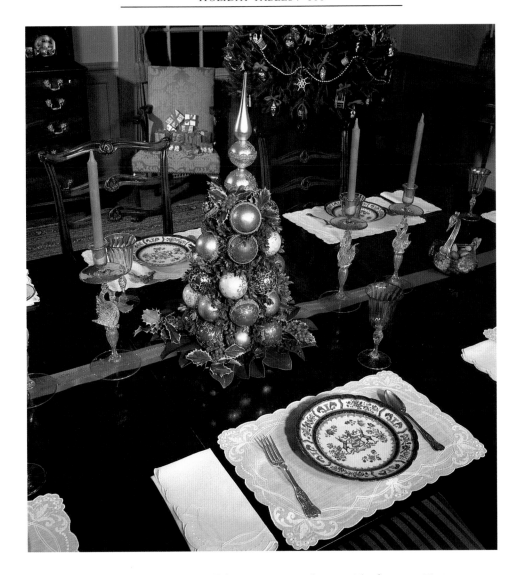

A festive table at Bassett Hall features a central pyramid of ornate Christmas
tree balls. A small tabletop tree is glimpsed in the background.

AT BASSETT HALL THE TABLE is set for Christmas dinner. Ornate gold and red Christmas tree balls are organized in a cone form on a bed of magnolia and variegated holly leaves and berries. Boxwood is used as a filler and more holly is placed near the top. Bayberry candles in Venetian glass swan candlesticks are arranged on a red ribbon near nut-filled glass swan dishes from the same set.

John D. Rockefeller, Jr., enjoyed using a hand-painted set of French Samson porcelain that was made to duplicate Chinese export porcelain. The embroidered place mats and napkins belonged to Mrs. Rockefeller.

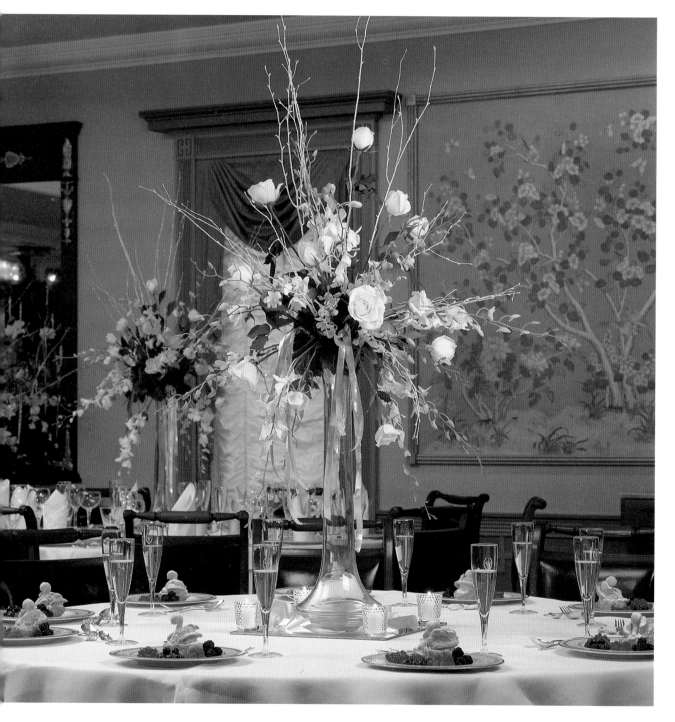

The elegant Williamsburg Inn is readied for a holiday dinner. Magnificent arrangements in tall glass holders cascade over glasses of champagne and pastry swans on beds of fresh berries.

AT THE WILLIAMSBURG INN white dendrobin orchids, pale pink Lady Di and white Jack Frost roses, galax leaves, white lilacs, and white birch branches placed in tall crystal holders form elegant cascades. Small votive candles on mirror bases reflect the billowing arrangements of flowers, silver ribbons, and lights. The Regency Room, ringed with snow-covered trees, tiny white lights, and cypress and white birch branches hung with icicles, sparkles in its winter setting.

A glorious dessert of cream-filled pastry swans surrounded with tiny pyramids of fresh blackberries, raspberries, blueberries, and ling-onberries greets each guest.

PASTRY SWANS *8 servings*

CHOUX PASTRY

PASTRY CREAM CUSTARD
1¼ cups sugar
9 tablespoons cornstarch
4 large eggs
1 quart milk
¼ cup butter
2 teaspoons vanilla

Mix the sugar and cornstarch together. Stir in the eggs and a small amount of the milk to make a thick liquid. In a heavy saucepan bring the remaining milk to a boil and pour the egg mixture into the milk all at once, stirring constantly with a wire whisk. Bring the mixture back to a boil, stirring constantly. Remove the mixture from the heat and add the butter. Stir until smooth. Add the vanilla. Stir frequently and, when almost cool, refrigerate.

CHOUX PASTRY
1 cup water
½ cup butter, cut in pieces
1 cup unsifted all-purpose flour
⅛ teaspoon nutmeg

4 large eggs
4 ounces semisweet chocolate, melted
powdered sugar

Preheat the oven to 425° F. Lightly grease two baking sheets or line them with parchment paper. Place the water and butter in a heavy saucepan and slowly bring to a boil. Mix the flour and nutmeg and add all at once, stirring vigorously with a wooden spoon until the dough forms a ball and leaves the sides of the pan. Remove from the heat. Make a well in the center of the dough and add the eggs one at a time, mixing thoroughly with a wooden spoon after each addition. The mixture will separate after each addition but will come back together quickly. Using a pastry bag with a ¾-inch round tube opening, pipe ¾ of the mixture into 8 4-inch rounds on a prepared baking sheet to form the swan bodies. Pipe the remaining mixture in 8 S-shapes about 3½ inches long on the second baking sheet to form the heads and necks. Bake at 425° F. for 20 minutes. Reduce the heat to 350°, and bake 10 to 15 minutes more or until golden brown. Check the S-shaped pieces after 15 minutes and remove from the oven when they are light golden brown. Cool on a rack. As soon as the bodies have cooled slightly, cut the top off each round, and then cut the top into two pieces. These will become the wings. Scrape any uncooked dough from the insides of the bodies and the wings to prevent them from becoming soggy. When the S-shaped pieces and wings have cooled, dip the ends of the necks and the wings into melted chocolate to prevent them from becoming soggy when they are put into the custard. Immediately before serving, fill each swan with the pastry cream custard, mounding the custard into the bodies. Place the chocolate-dipped heads and wings into the custard. Dust with powdered sugar.

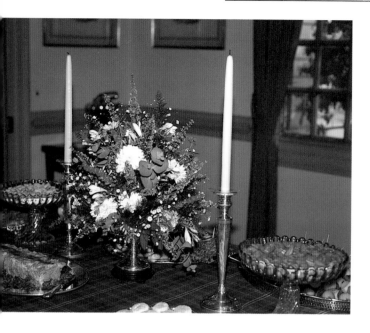

FOR A CHRISTMAS COCKTAIL SUPPER, holiday heather is brought into the house and arranged on a table dressed in an ancient tartan in keeping with a long-held family tradition.

A country pâté, thinly sliced beef tenderloin, fruit kabobs, grilled vegetables, miniature crab cakes, and grilled chicken rosemary await the guests.

GRILLED CHICKEN ROSEMARY

1 large clove garlic, minced
3 tablespoons lemon juice
1½ teaspoons Dijon mustard
½ cup olive oil
1 teaspoon soy sauce
1 teaspoon salt
½ teaspoon freshly ground pepper
1 tablespoon dried rosemary
8 to 12 boned chicken breasts, skin removed,
 slightly pounded to make evenly thin
sprigs of fresh rosemary and fresh thyme

Combine all the ingredients except the chicken and the fresh herbs and process in a food processor. Pour some of the mixture into the bottom of a ceramic or glass dish. Layer the chicken on the bottom and cover it with sprigs of fresh rosemary and thyme. Sprinkle the mixture over this layer. Repeat until all of the chicken is layered. Refrigerate. Oil the grill and cook the chicken over hot coals on a bed of the fresh herbs used in the marinade, turning after 2 or 3 minutes. Check to see if the chicken is done after 2 more minutes. Cool. Slice on the diagonal and serve with whole-grain bread.

GRILLED MARINATED VEGETABLES

½ cup herb-flavored olive oil
4 tablespoons lemon juice
3 cloves garlic, minced
1½ teaspoons salt
freshly ground pepper
½ cup fresh basil
⅓ cup fresh thyme
3 small eggplants
3 small zucchini

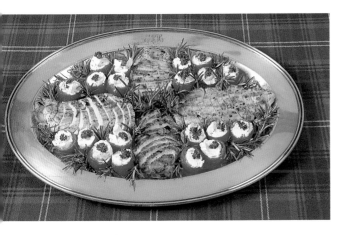

salt
black pepper
¼ cup mushrooms, minced (optional)
8 to 12 English muffins
olive oil
thin slices of Virginia ham

Pick over the crabmeat and discard any bits of shell. Sprinkle the lemon juice over the crabmeat and gently mix. Set aside ½ cup of bread crumbs. Add the mustard, mayonnaise, egg, Tabasco sauce, butter, salt, pepper, and mush-

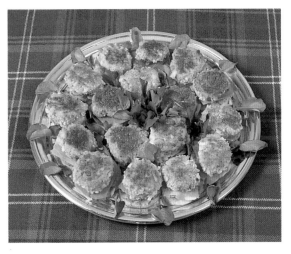

3 small summer squash
2 red peppers
2 yellow peppers

Mix the olive oil, lemon juice, garlic, salt, pepper, and herbs together to make a marinade. Cut each vegetable into wedges. Place each vegetable into its own glass or ceramic dish with some of the marinade and toss well. Cook on a well-oiled grill over medium-hot coals approximately 10 minutes or until the vegetables are soft and browned on both sides, turning once. The eggplants and peppers will take longer than the squash.

MINIATURE CRAB CAKES AND VIRGINIA HAM ON TOASTED ENGLISH MUFFIN SLICES

6 dozen 1½-inch cakes

1 pound backfin crabmeat
3 tablespoons lemon juice
1½ cups bread crumbs, divided
3 teaspoons Dijon mustard
1 tablespoon mayonnaise
1 egg, lightly beaten
2 dashes of Tabasco sauce
1 tablespoon butter, melted

rooms with the remaining bread crumbs to the crabmeat. Dust the surface of a jelly roll pan with some of the remaining bread crumbs. Form the crabmeat mixture into patties and carefully place them on the bread crumbs. Sprinkle the tops with crumbs and pat them gently into the mixture. Chill overnight. Sauté the cakes in butter in a moderately hot pan until both sides are nicely browned. Using a whole English muffin, cut out 1½-inch rounds with a cutter (3 rounds per muffin). Slice into 2 or 3 sections, brush with olive oil, and broil until the tops are golden. Top each with thinly sliced Virginia ham and a crab cake.

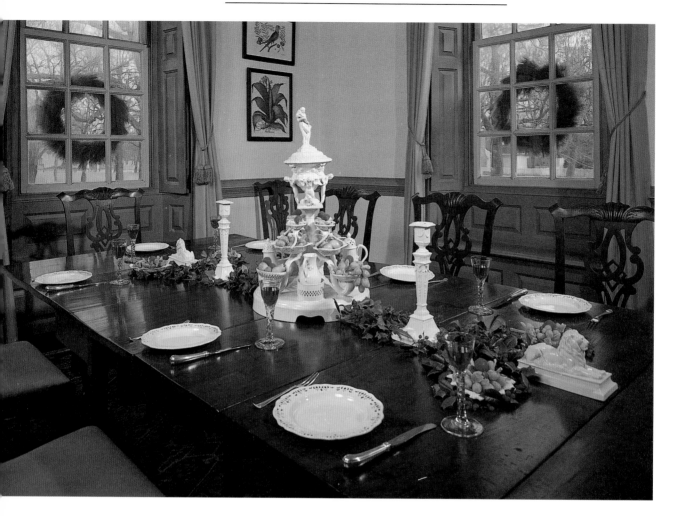

A TREASURED PIECE OF LEEDS
CREAMWARE is given the place of honor on
this lovely old table. The tiny baskets are filled
with sugared nuts, marzipan fruits, grapes, can-
died fruit peels, and tiny lady apples. A pleas-
ing arrangement of greenery extends from the
epergne to the ends of the table. A narrow
band of holly sprigs circles the candlesticks and
forks on either side of the ceramic lion figures.
Small creamware dishes of grapes, candied fruit
peels, nuts, and marzipan are ringed with Amer-
ican holly.

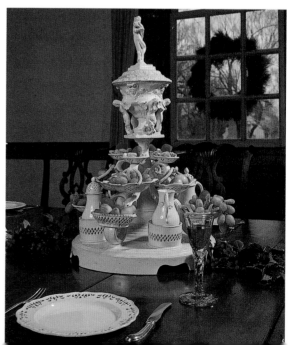

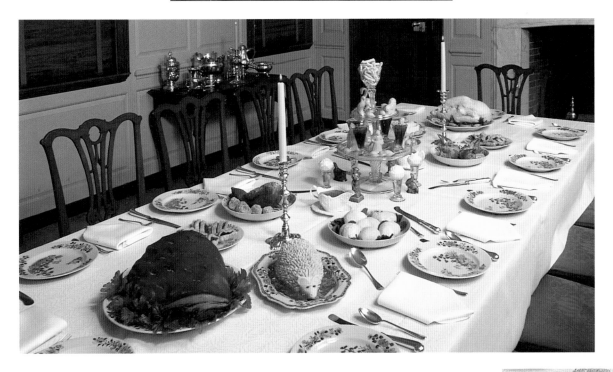

AT THE PEYTON RANDOLPH HOUSE a table set for supper displays the traditional symmetrical arrangement of foods. A Virginia ham balances a turkey in oyster sauce, while roasted quail and tongue are arranged opposite a fricassee of chicken and ballons of fowl. A disarming little marzipan hedgehog catches our eye. An adaptation has been devised that is purely decorative, but an edible form may be made with a cheese base decorated with nuts.

MARZIPAN HEDGEHOG

4 to 6 rolls of marzipan,
 depending on the finished
 size of the hedgehog
Styrofoam block or
 box 2 inches smaller than
 the finished size of the hedgehog
currants
slivered almonds

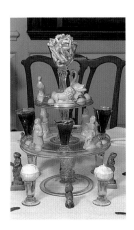

Hannah Glasse described a dessert pyramid in her early cookbook, *The Compleat Confectioner:* "Two salvers one above another, whip'd syllabubs and jellies intermix'd with crisp'd almonds, and little ratafia cakes, one little one above all, with preserved orange . . . and knicknachs strew'd about the salver."

Knead the marzipan to the consistency of clay. Use the softened marzipan to form the shape of the hedgehog over a Styrofoam block or a box 2 inches smaller than the finished size of the hedgehog. Make a roll for the "ruff" around the neck, and model the face and the ears. Use currants for eyes. Insert slivered almonds into the marzipan for the spines.

boxwood and pomegranates is placed between two swags similar to those on the table.

2. A large and colorful Grinling Gibbons S-curve of fruits and nuts is the focal point of this dessert table. To a base of magnolia leaves, variegated holly, and lemon leaves, colorful pomegranates, lady apples, purple grapes, lemons, limes, and other fruits and nuts were added. The base for this arrangement is a Styrofoam wreath form cut in half. The curves are reversed to form an S-shape. All materials were wired or impaled on floral picks and inserted into the Styrofoam base (see page 52). A cone of osage oranges is on the sideboard, and the painting over the fireplace is garlanded with pine roping and red bows.

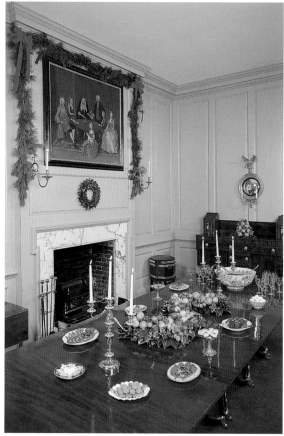

ONE ROOM THREE WAYS AT CARTER'S GROVE is pictured on these pages.

1. Restrained elegance is the chief characteristic of this delicate S-curved table decoration, which is constructed on a central wire (see pages 41 through 43) using a variety of interesting materials. Red pomegranates, cockscomb, rose hips, and staghorn sumac blooms provide the color accents with the shiny green boxwood sprigs. Modern interpretations of the carved garlands made by the seventeenth-century English artisan Grinling Gibbons, famous for his wood carvings of plant materials, hang on the mantel face. A variety of cones, nuts, and leaves with

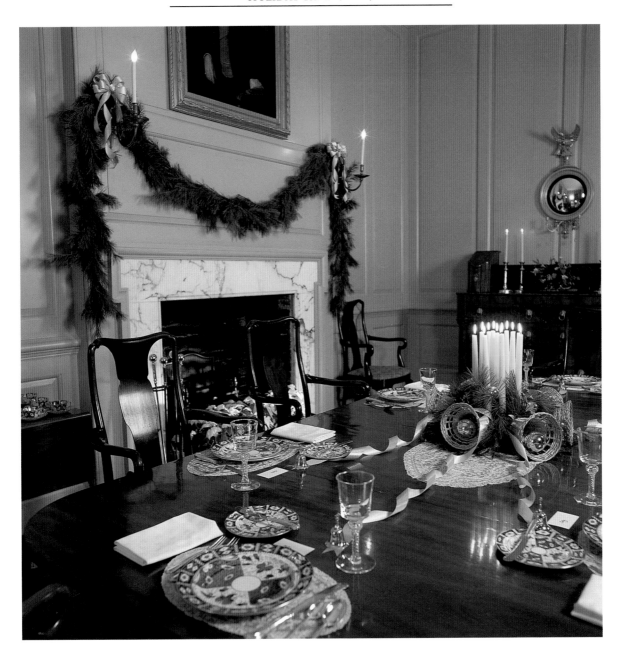

3. New Year's Eve in the same room reveals a grand arrangement of gold-painted wicker bells, with gold balls for clappers. Surrounding the bells is a massed design of a dozen white candles set on an antique lace runner. White pine and holly are tucked in, and gold ribbons spiral across the table. Pine roping is swagged over the face of the mantel and is secured to the sconce arms with festive gold bows. Places are set for dinner using the Carter's Grove china.

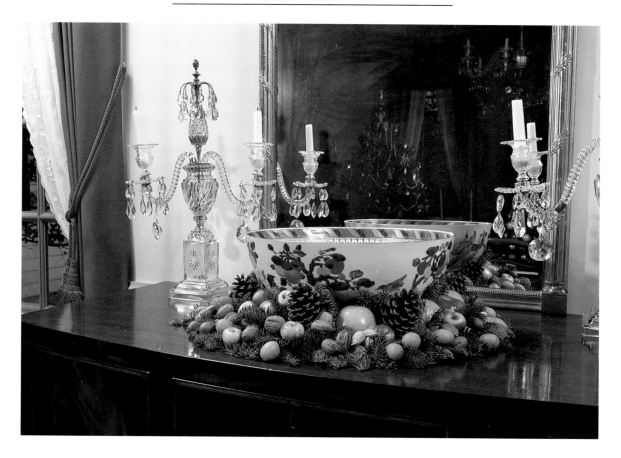

A CHINESE EXPORT PUNCH BOWL on the sideboard in the dining room at Bassett Hall is elegantly ringed with loblolly cones, yellow and orange kumquats, lady apples, and oranges. Scatterings of pecans, walnuts, and almonds with bushy sprigs of balsam are added for a contrast in texture. A tabletop Christmas tree is reflected in the grayed glass of a giltwood mirror. The candelabra are English cut glass and date from the eighteenth century as does the mahogany sideboard.

The construction of this wreath is similar to the one on the opposite page. Notice the difference in the two color combinations and the effect created by the way this wreath is built up against the base of the bowl rather than being a separate ring on the table surface.

WASSAIL *20 servings*

1 cup sugar
4 cinnamon sticks
3 lemon slices
2 cups pineapple juice
2 cups orange juice
6 cups dry red wine
½ cup lemon juice
1 cup dry sherry

Boil the sugar, cinnamon sticks, and lemon slices in ½ cup of water for 5 minutes and strain. Discard the cinnamon sticks and lemon slices. Heat but do not boil the remaining ingredients. Combine with the syrup, and serve hot.

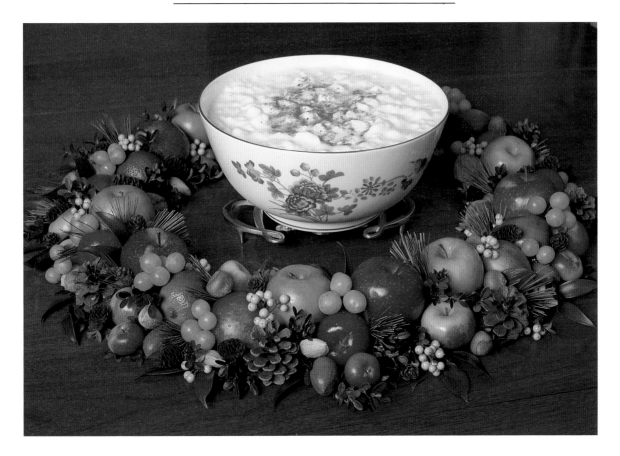

COLONIAL WILLIAMSBURG'S REPRO-DUCTION PUNCH BOWL is surrounded by this simple yet lovely wreath of red and green tones. Place a doughnut-shaped piece of heavy plastic on the table to protect its surface. The size of the plastic piece will be determined by the area to be covered by the wreath. If it will be placed around a bowl as shown here, work with the bowl in place.

Lay the largest fruits and cones on the plastic piece, distributing them evenly by size and color. Add smaller fruits next, and fill in with the berries, nuts, and greens.

This wreath can also be used by itself as a table centerpiece and can be made quickly.

EGGNOG

12 servings

6 eggs, separated
½ cup sugar
2 cups whipping cream
1 cup milk
½ cup bourbon
½ cup brandy
½ cup light rum
nutmeg

Beat the egg yolks with the sugar until thick. Slowly add the cream, milk, and spirits. Chill. Whip the egg whites until soft peaks form and add to the mixture. Chill and let ripen a few hours. Sprinkle with nutmeg before serving.

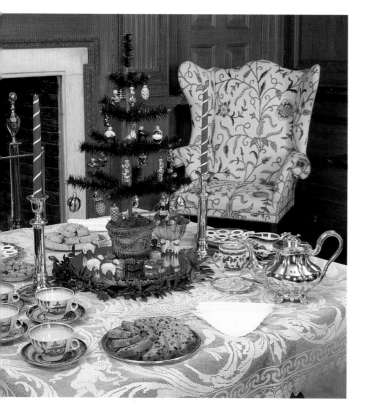

FOR A TEA AT CARTER'S GROVE, an elegant table is set by the fire. Tabletop feather trees have become enormously popular, but the residents at Carter's Grove would have known them in the mid-1860s as the newest fashion. These trees were made with real goose feathers secured to wire branches that were attached to a wooden dowel trunk. They were first made in Munich to imitate the sparsely branched German white pines and provided an ideal place to feature special ornaments. This tree is displayed on a mirrored plateau with an assortment of tiny packages and is watched over by a flock of small fleece-covered sheep. Candles wrapped with ribbons are placed on either side of the table.

CURRANT NUT TEA CAKE

1 cup butter
½ cup granulated sugar
½ cup light brown sugar
5 eggs
1 tablespoon lemon juice
2 cups plus 1 tablespoon all-purpose flour
½ teaspoon baking powder
½ teaspoon cinnamon
½ teaspoon nutmeg
1½ cups currants
½ cup walnuts, chopped

Preheat the oven to 325° F. All of the ingredients should be at room temperature. Grease well and lightly flour a 9¼- x 5¼- x 2¾-inch loaf pan. Cream the butter and sugars. Add the eggs, 1 at a time, beating well after each addition. Add the lemon juice. Sift 2 cups of flour with the baking powder, cinnamon, and nutmeg. Gradually add the flour mixture to the egg mixture. Dust the currants and walnuts with the remaining 1 tablespoon of flour so they do not sink to the bottom of the mixture. Fold the currants and walnuts into the mixture. Bake in a preheated 325° F. oven for 1 hour and 20 minutes or until done. Cool in the pan for 10 minutes before turning out onto a rack. Slice thinly.

How to Make a Feather Tree of Boxwood

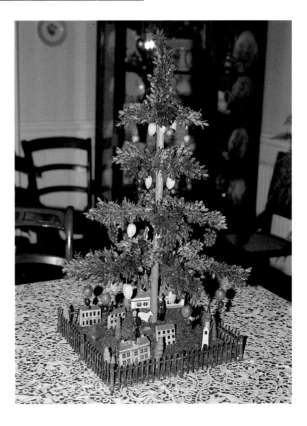

Supplies and materials needed: 20-inch-long straight branch, drill and bit the diameter of the wire, plaster of paris, container, small plastic pot, clothesline wire, wire cutters, green floral tape, spool wire, needle and thread, plant mister, conditioned plant materials (see page 136), berries, nuts, pods, moss, and accessories.

The tree illustrated here is 25 inches tall and is constructed like the original feather tree, but here boxwood rather than feathers is used. Follow the general proportions and directions shown here to make your tree. Although the form takes time to make, it can be saved and used another season.

Divide the trunk into 4 horizontal levels or tiers before drilling the holes for the wires (see figure 1). For the bottom level (level 1), divide the circumference into 3 parts and drill 3 equally spaced horizontal holes. For levels 2 to 4, drill 2 horizontal holes at right angles to each other for each tier. Do this very carefully, leaving approximately ¼-inch space above or below each hole so that the wires may pass through the trunk (see figure 2). Vary the placement of the branches by drilling each tier's holes between the branches of the tier directly below to give the

This adaptation of the goose feather tree opposite retains the same sparsely branched look of the original form, but here it is made of boxwood. Instead of blown-glass ornaments, decorations include rose hips, cranberries, nandina berries, and almonds. It is placed on a moss carpet and is surrounded by a fence and an old wooden village, similar to the ones that inspired Colonial Williamsburg's reproduction village.

tree a fuller look (see figure 2). Using the same drill bit make a 1-inch-deep hole down into the top of the trunk.

After the 10 holes are drilled, mix the plaster of paris in the container. Place the branch into the small plastic pot and pour 1¼ to 2 inches of the plaster of paris into the pot. Be sure to tape over any holes in the pot. Be care-

ful to have the tree trunk perfectly vertical and allow the plaster of paris to harden.

Cut the clothesline wire as follows: 3 15-inch pieces, 2 11-inch pieces, 2 7½-inch pieces, 2 5½-inch pieces, and 1 4½-inch piece. When the plaster of paris is dry, insert the longest wires through the bottom holes. Make sure the branches in each tier are the same length. The 4½-inch piece of wire is inserted into the hole at the top of the trunk and will be the top of the tree. Wrap the branches with green floral tape as shown in figure 3.

Starting at the outside ends of the branches, attach 3-inch-long bunches of boxwood around the clothesline wire by wrapping the

stem ends to the wire branches with spool wire as for a double-faced wreath (see page 9). Continue to attach overlapping bunches of boxwood, covering the stem ends, around the wire branches. Keep the bunches close together to get a pleasingly full effect. Continue to wire the bunches along the branch ending at the trunk. Repeat this process on all branches including the top. Mist well.

Ornaments of berries, nuts, and pods strung on thread, shown below, may be hung from the branches. A village ringed by a fence was placed on a bed of moss. Other accessories may be added around the bottom of the tree, or the tree may be placed in an ornamental container.

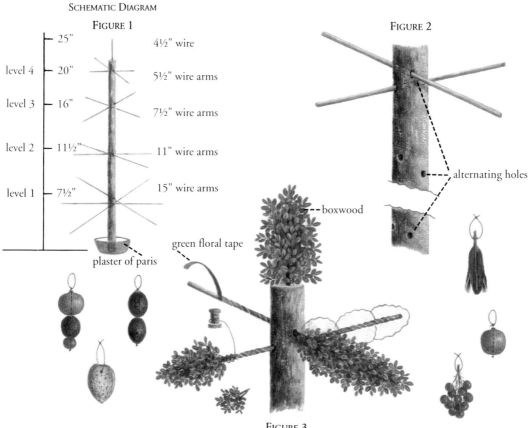

SCHEMATIC DIAGRAM

FIGURE 1

FIGURE 2

FIGURE 3

CENTERPIECES other than flowers are used at Christmas. They range from the temples shown on the Palace and Craft House tables and the pyramid of salvers at the Peyton Randolph House to this miniature gazebo which is decorated for Christmas. It is placed in a replica of a colonial garden with crushed oyster shell paths. Cryptomeria, red nandina berries, and miniature Kingsville boxwood form garlands on the doorway. A tiny kissing ball of lacopodium hangs inside from a red ribbon. A pair of cardinals perches on the rooftop while a titmouse examines a bird bottle. Red cedar and Kingsville boxwood serve as hedges and trees.

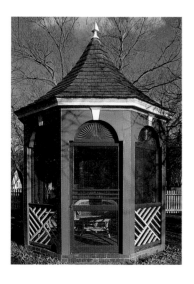

A table-size miniature gazebo *(above)*, decorated for Christmas, is based on one in the garden at the Blue Bell *(left)*.

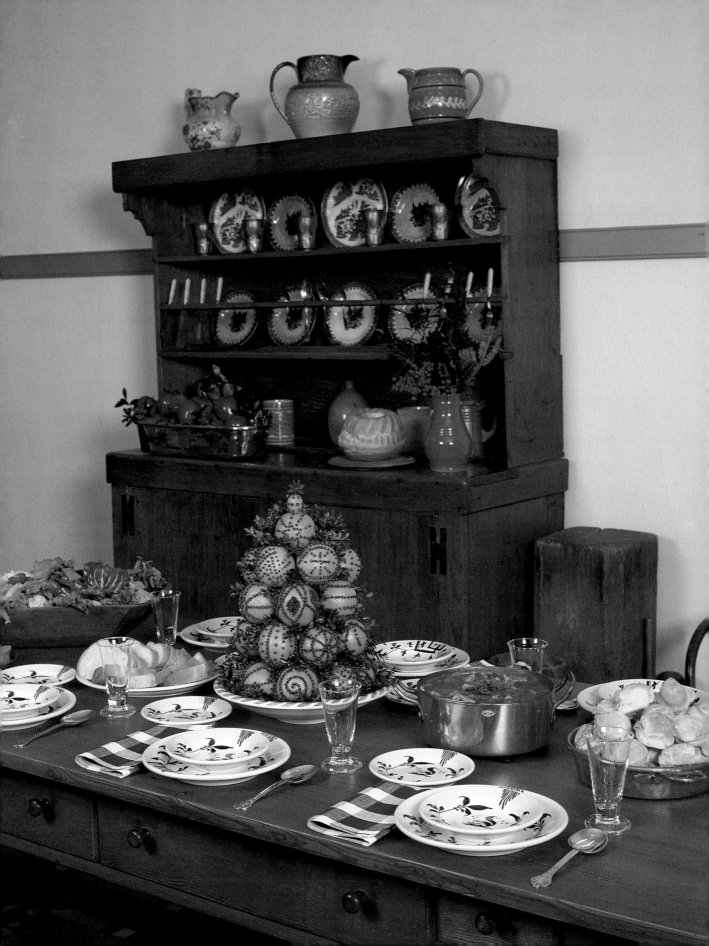

A HOLIDAY PLANTATION SUPPER AT CARTER'S GROVE includes hot Brunswick stew, Virginia ham in beaten biscuits, and a salad of mixed greens. A large loaf of Sally Lunn bread and small corn muffins are long-time tidewater favorites. A cone of pomandered oranges lends a fragrant air to the table (another version is shown on page 62). Greens and berries are arranged in a ceramic bird bottle on the cupboard.

BRUNSWICK STEW *8 to 10 servings*

Traditionally Brunswick stew was made with squirrel, but this recipe substitutes chicken. Amounts of each ingredient in this hearty stew can be increased or decreased according to taste.

1 stewing hen (6 pounds)
 or 2 broiler-fryers (3 pounds each)
6 cups fresh tomatoes or
 3 cans (1 pound each)
4 cups corn cut from cob or 2 cans
 (1 pound each)
2 cups butter beans
2 cups okra, cut
4 large potatoes, diced
2 large onions, chopped
3 slices bacon, minced

2 cups cooked black-eyed peas
2 teaspoons sugar
3 teaspoons salt
1 teaspoon pepper

Cut the chicken into pieces and simmer it in 3 quarts of water for a thin stew or 2 quarts of water for a thick stew until the meat can easily be removed from the bones, about 2¼ hours. Remove, chop into small pieces, and reserve. Add the vegetables and bacon to the broth and simmer, uncovered, until the beans and potatoes are tender. Add the chicken and the seasonings.

NOTE: Brunswick stew is even better if it is left to stand overnight and is reheated the next day.

Opposite: The large kitchen at Carter's Grove is the scene of this hearty plantation supper. Ham biscuits, piping hot Sally Lunn bread, corn muffins, and a green salad accompany Brunswick stew. Christiana Campbell's Tavern pottery and glasses, checked napkins, and a pomandered orange cone create a cheerful table.

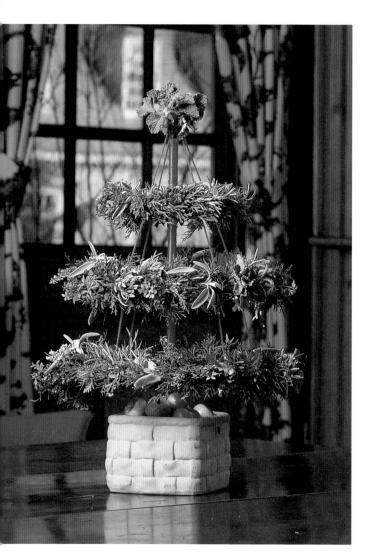

Herbs and plant materials used in these three tiers include rosemary, sage, germander, thyme, lavender, horehound, rue, lamb's ear, cedar, and tiny red peppers. Small lady apples surround the base.

How to Make a Tiered Herb Tree

Materials and supplies needed: plaster of paris, container, ½-inch dowel 18 inches long, small plastic pot, clothesline wire, wire cutters, green floral tape, spool wire, plant mister, red ribbon and cording, white glue, large tack, ornamental container, gravel, and conditioned plant materials (see page 136).

This fragrant tabletop tree of herbs is fun to make, and the forms can be saved and used another season. If the plant materials are wired very closely together, the tree may be used dried.

Mix the plaster of paris in a separate container. Place the 18-inch-long dowel into a small plastic pot, with any holes taped over, and pour approximately 1½ to 2 inches of the plaster of paris into the pot. Be careful to have the dowel perfectly vertical and allow the plaster of paris to harden.

Make three circles of wire with diameters 5½ inches, 7½ inches, and 9½ inches. When bent, the ends should overlap approximately 1 inch. Wrap each circle with green floral tape (see figure 1). Divide your plant materials so that you will have similar kinds for each tier. Hold a small bunch (approximately 2- to 3-inch pieces) of plant materials on the frame and wrap the spool wire around the herbs and frame several times so that the materials are securely fastened to the frame (see figure 2). Be sure to cover both sides of the circular wire forms evenly as in a double-faced wreath (see page 9) so that they will be bushy and full.

Continue around the frame attaching small

bunches of herbs with spool wire and spacing the accent pieces, such as the lighter-colored sage, lamb's ear, or lavender, at regular intervals. The last bunch should be wired underneath the first bunch you attached by lifting the foliage end of the first bunch and wrapping the last bunch tightly under it. Repeat with the remaining wire forms. Mist well.

Wrap the ribbon diagonally around the dowel and glue the ribbon to the dowel at both ends. Cut the cording into 2 lengths, each about 40 inches long. Hold the 2 pieces together and make a single knot in the center. Put the tack through this knot and into the top of the dowel to make 4 equal streamers (see figure 3) and to secure the cording. Each of the 4 pieces will measure approximately 20 inches. Place the plastic pot with the wrapped dowel and attached cording into the outer container (this pot is 4 inches high, 5 inches x 5 inches

wide) and fill the pot with gravel to stabilize it.

Put the largest wreath over the top of the dowel and rest it on the table surface. Next place the medium-size wreath over the dowel and rest it on top of the larger wreath. Put the smallest wreath over the dowel and tie the 4 pieces of cording evenly around it (see figure 3) so that it hangs evenly and is parallel with the table surface approximately one-quarter of the distance down from the top of the dowel to the top of the container (see figure 4). Repeat this process with the other 2 wreaths, being careful to space them evenly as shown. Tie the cording securely around the bottom wreath and trim the ends.

Add the tiny peppers around the wreaths for accent. A bunch of herbs at the top may be wrapped with wire and attached to the tack. Add tiny lady apples for color around the top of the container.

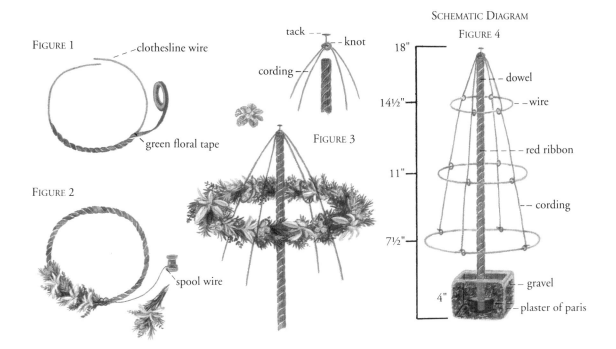

SCHEMATIC DIAGRAM
FIGURE 4

FIGURE 1
clothesline wire
green floral tape

FIGURE 2
spool wire

tack
knot
cording
FIGURE 3

18"
14½"
11"
7½"
4"
dowel
wire
red ribbon
cording
gravel
plaster of paris

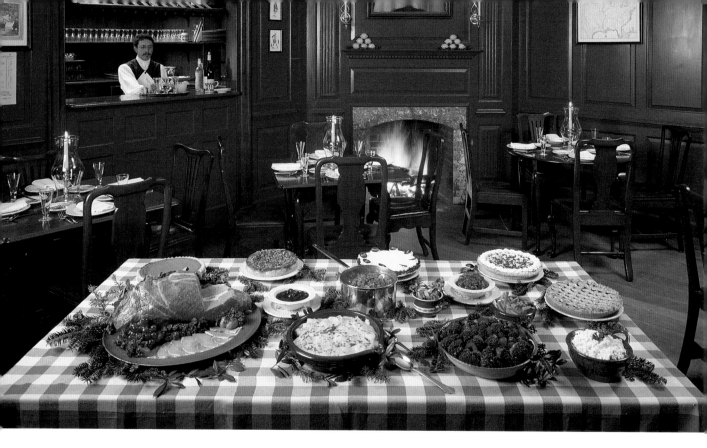

A sumptuous table set for a holiday dinner at the King's Arms Tavern features a hearty and tempting array of foods. A baked Virginia ham, a casserole of lobster and crabmeat, broccoli, relishes, and winter vegetable soup are accompanied by a selection of pies including pumpkin, pecan, white chocolate mousse, rum cream, and mincemeat.

A DELICIOUS DINNER AT THE KING'S ARMS TAVERN features a Virginia ham. Always a favorite, a beautifully garnished ham and a winter vegetable soup are perfect accompaniments for the lobster and crabmeat Dijonnaise.

WINTER VEGETABLE SOUP

10 to 12 servings

6 cups turkey or chicken stock
4 celery ribs and tops, diced
⅓ cup parsley, minced
1 bay leaf
3 tablespoons butter
4 carrots, peeled and diced

1 small onion, finely chopped
2 leeks (white part plus one inch of green), sliced
3 cloves garlic, minced
3 cups plum tomatoes, chopped
1 cup peas
1 teaspoon thyme
1 teaspoon rosemary
½ cup Madeira or medium-dry sherry

cayenne
3 cups cooked dark meat turkey or chicken,
 finely chopped (optional)
salt or lemon juice
pepper
¼ cup red bell pepper, diced
fresh rosemary sprigs

Bring the stock to a boil and add the celery, parsley, and bay leaf. Simmer for 20 minutes. Melt the butter in a deep saucepan and add the carrots, onion, leeks, and garlic. Cover and cook over low heat for about 15 to 20 minutes until the vegetables are tender and add them to the stock. Add the tomatoes, peas, thyme, rosemary, Madeira or sherry, and a dash of cayenne to the stock. Bring to a boil, immediately lower the heat to high simmer, and cook for 15 minutes. Add the turkey or chicken, if desired, and cook for 5 minutes more. Season to taste, garnish with red bell pepper and fresh rosemary sprigs, and serve.

LOBSTER AND
CRABMEAT DIJONNAISE *10 servings*

10 frozen patty shells
1 pound backfin crabmeat
4 teaspoons lemon juice
3 tablespoons butter
¼ cup shallots, minced
1 pound lobster meat
2 cups SUPREME SAUCE
salt
white pepper
10 thin slices Virginia ham
¾ cup DIJONNAISE SAUCE

Preheat the oven to 450° F. Place the patty shells upside down on an ungreased baking sheet. Reduce the heat to 400° F. and bake for 20 minutes. Cut each shell in half, cutting away the sides so that a flat crouton is left. Brown the croutons lightly. Reserve. Pick over the crabmeat. Discard any bits of shell. Toss the crabmeat gently with the lemon juice. Melt the butter in a small skillet. Add the shallots and sauté over medium heat until soft. Do not brown. Add the crabmeat and lobster and sauté over low heat for 5 minutes, tossing gently so that the seafood is well coated with butter. Add more butter if needed. Add the Supreme Sauce, season with salt and white pepper to taste, and cook for about 10 minutes on low heat. Place the croutons on a cookie sheet and cover each with a slice of Virginia ham. Top with about ¾ cup of the hot seafood mixture. Cover with the Dijonnaise Sauce. Place under the broiler until the Dijonnaise Sauce has slightly browned.

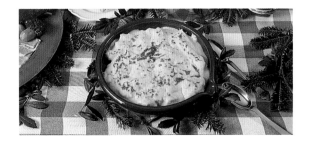

SUPREME SAUCE
4 tablespoons butter
1 small onion, grated
4 tablespoons all-purpose flour
2 cups hot milk or 1 cup hot milk and
 1 cup hot chicken stock
¼ teaspoon salt

Heat the butter and onion together but do not brown. Stir in the flour and remove from the

heat. Add the hot milk or milk and chicken stock, then the salt, and continue to stir rapidly until the sauce is smooth. Return to the heat and stir continuously until the sauce comes to a boil. Gently simmer and stir 3 to 5 minutes longer. Strain through a fine sieve.

DIJONNAISE SAUCE
1 teaspoon butter
1 teaspoon flour
2 tablespoons milk
3 egg yolks
1 tablespoon lemon juice
3 tablespoons whipping cream
6 tablespoons butter, cut in small pieces
salt
cayenne
1½ teaspoons Dijon mustard

Melt 1 teaspoon of butter in a small saucepan. Stir in the flour and cook over medium heat for 3 minutes, stirring constantly. Do not let the mixture brown. Add the milk, whisking until the cream sauce is thick and smooth. Reserve. Whisk the egg yolks, lemon juice, and whipping cream over medium heat just until the mixture begins to thicken. Remove from the heat and gradually add the 6 tablespoons of butter, whisking constantly. Add salt and cayenne to taste. Stir in the mustard and the reserved cream sauce.

WHITE CHOCOLATE MOUSSE PIE

1 10-inch pie shell
5 egg whites
½ cup granulated sugar
1 teaspoon gelatin
1 tablespoon water
1 tablespoon Kirsch
8 ounces white chocolate
2 cups whipping cream

¼ cup miniature chocolate chips
chocolate sprinkles

Bake the pie shell. Heat the egg whites and sugar in a double boiler over simmering water, stirring constantly until they feel very warm to the touch. Put them in a mixer and whip to a smooth meringue. Soften the gelatin in 1 table-spoon warm water in a small pan. Add the Kirsch, and simmer until the gelatin is dissolved. Pour the gelatin into the meringue and whip at medium speed until it comes to room tempera-ture. Melt the white chocolate over hot, not boiling, water in the double boiler making sure that the bottom of the pan does not touch the water. Whip the cream until stiff. Mix a little meringue into the melted chocolate and then fold it into the meringue mixture. Gently fold in the whipped cream and chocolate chips. Spoon into a 10-inch pre-baked pie shell. The edge of the pie may be decorated with chocolate sprinkles. Refrigerate for several hours.

PECAN PIE

1 9-inch pie shell
3 eggs
1 cup light brown sugar, packed
¼ teaspoon salt
½ cup light corn syrup
½ cup butter, melted
½ teaspoon vanilla
1½ cups broken pecan halves
½ cup unbroken pecan halves

Preheat the oven to 350° F. Beat the eggs light-ly and add the sugar, salt, corn syrup, cooled butter, and vanilla; stir until mixed well. Spread the broken pecan halves on the bottom crust and cover with the filling. Spread the unbroken halves on the top. Bake for 35 to 40 minutes or until the mixture is firm in the center.

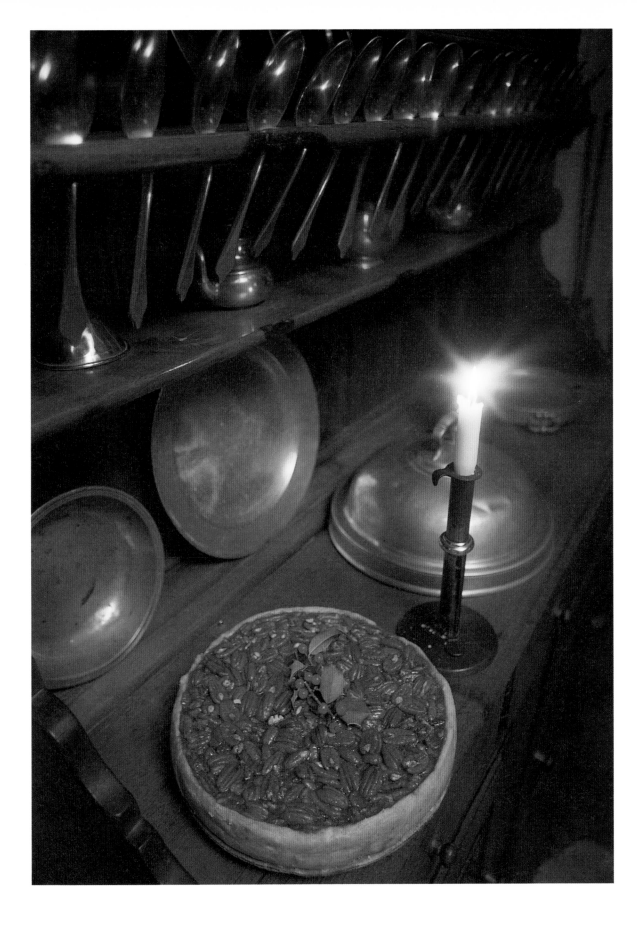

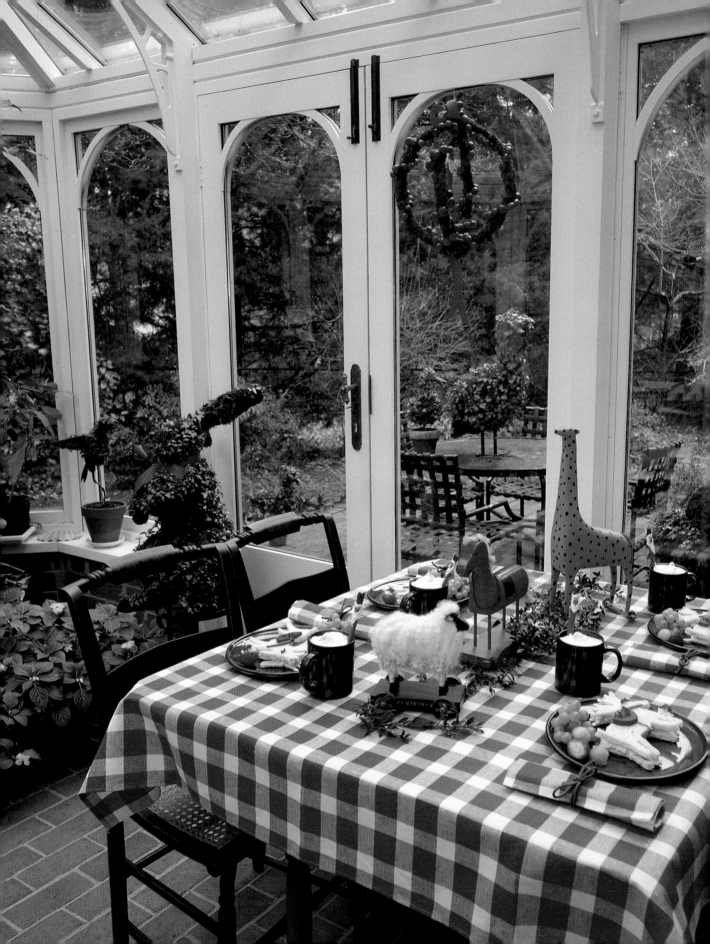

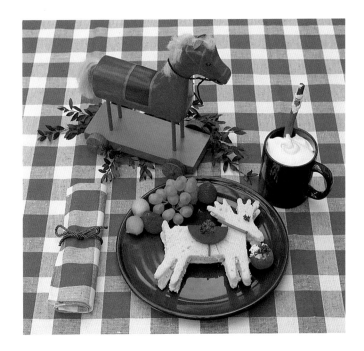

A CHILD'S PARTY at Christmastime features a brightly colored red and white checked cloth and toys from Colonial Williamsburg's reproductions program, which prance across the table. The sandwich is cut with a reindeer cookie cutter. The engaging fellow wears a bright red saddle, made from a spiced apple slice and parsley, and chive reins. Tasty fruit garnishes the plate and a Santa-decorated cinnamon stick is handy to stir the hot chocolate.

A mossed kissing ball hangs above the table, and assorted topiary creatures—an elephant, a family of ducks, a giant rabbit, and a tiny hummingbird—are special guests at Abby's party.

Conditioning and Use of Plant Materials
General Information and Suggestions

IF care is taken to condition the greens and flowers you use in your holiday decorations, your efforts will be well rewarded. Properly conditioned plant materials will remain fresh much longer with this care. It is always well to cut and condition more than you think you will use in order to have an ample supply. Thus you may choose the freshest and strongest materials for your project. Evergreens may be cut at Christmastime. Boxwood particularly needs to have the sun penetrate into its center for healthy growth and therefore benefits from being pruned.

Before cutting or purchasing material, be aware of protected species in your area. Do not use this material or purchase it from a vendor. For example: the amount of the slow-growing princess pine needed to make one wreath (frequently it is seen with its roots attached indicating the whole plant was pulled from the ground) can represent a substantial loss to its original habitat.

If your finished product will be in the full sun, select your materials accordingly. Cones, pods, and nuts will fare far better than fruit on a wreath that faces the sun much of the day. Balsam or spruce will not dry out and turn brown as quickly as white pine.

If you live in an area where the temperatures are frequently below freezing, remember that most fruits are damaged and change color when frozen and thawed.

In the Williamsburg area, squirrels and birds enjoy our fruit wreaths!

Conditioning Foliage

Always use clean, well scrubbed, and disinfected containers. Household bleach will kill most bacteria and other organisms. Rinse well.

When cutting, it is best to carry pails of water so that the cut materials can go directly into water. Carry deep or small pails depending upon the materials being cut. Do not crowd the plant materials in the containers. Cut all stems at an angle. Remove any broken or dead stems and leaves. Allow the materials to condition overnight in a cool place before you arrange them. After conditioning, mist the materials frequently or use a floral shield (see Preservatives).

Evergreens with woody stems: (holly, magnolia, pines, boxwood, firs, cedar, arborvitae, and hemlock)

When you return from cutting, recut the stems, slit them about 2 inches with a sharp knife, scrape off the lower bark, and pound the stem ends to increase the plant's water intake. Submerge your materials, if possible, in warm water mixed with floral preservative (or 1 tablespoon glycerine per quart of water for smaller amounts) in a set tub, large pail, or even a bathtub for large amounts. The next day, cut the pieces to length with stems cut at an angle, remove all foliage below the waterline, and put the freshly cut stems into clean water until ready to use.

Evergreens with non-woody stems: (ivy, Alexandrian laurel, periwinkle, new growth aucuba, cleyera)

After returning from cutting, recut the stems. Submerge the materials, if possible, in warm water mixed with floral preservative in a set tub, large pail, or even a bathtub for large amounts. After overnight conditioning, cut the stems at an angle to length, remove all foliage below the waterline, and immediately stand in warm water until they are ready to be used. Ivy may be soaked in liquid floor wax and dried on newspapers.

Conditioning Flowers

General: Use clean containers with fresh water

(see Preservatives). Recut the stems at an angle and immediately put them in warm water at least one-half the length of the stems. Choose flowers not yet fully opened. Remove all foliage below the waterline. Condition overnight, if possible, away from the heat, sunlight, and drafts. Use boiling water for wilting flowers and warm water for those with very soft stems. Mist the arrangement frequently. If overnight is not possible, condition all flowers except those with soft stems (daffodils, tulips, and narcissi) in deep warm water for at least 4 hours; put those with soft stems in shallow warm water for at least 2 to 3 hours.

Specifics: (Here are a few flowers available at Christmastime that require special care)

Tulips—Recut stems, remove lower leaves, and, 4 stems at a time, roll the total length of the stems in newspaper to keep the stems straight. Place in a deep container of warm water overnight.

Daffodils, hyacinths, and narcissi—Condition in containers separate from other flowers in shallow water for at least 2 hours. They exude a slimy sap which is damaging to other flowers, but after conditioning, they can be added to an arrangement of mixed flowers.

Poinsettias, euphorbia, and other stems with milky, yellow, or colorless sap—Add 1 handful or rock salt per 2 quarts of water. Cut each stem and immediately hold it in a candle flame for a few seconds. Also do this for any area where a leaf or branch is removed. Poinsettias will hold for 12 hours out of water treated this way, or they can be singed and put into a container of water.

Chrysanthemums and all other woody stems—Recut the stems, slit with a knife at the bottom of the stem, and add oil of cloves to the conditioning water.

Preservatives

There are two basic types of floral preservatives:

1. *External floral shield products* such as Crowning Glory are available through your florist or floral supply outlet. These are designed to reduce moisture loss and are available in spray or powdered form. Following the directions, mix in a large container and submerge the material, if possible, or spray your tree, wreath, plaque, or roping to extend the life of the greens.

2. *General purpose floral preservatives* extend the vase life of a flower or foliage and are good to use when conditioning or in a container. These contain a food sugar, a biocide or antibacterial agent to keep the water fresher for a longer period, and a wetting agent to aid in the uptake of water. We also recommend soaking floral foam in a solution containing the preservative.

Other additives are given in the section on conditioning flowers and foliage.

Mechanicals

It is a good idea to have on hand a supply of various gauges of floral and spool wire, fern pins, wired and unwired wooden picks, floral tapes and adhesives, sharp clippers, wreath forms, clothesline wire, wire cutters, instant floral foam, and a variety of sizes of chicken feeders, plastic liners, floral foam cages, and other holders. With a basket of these supplies, you will be ready to tackle most projects once you have your plant materials prepared.

Leaves Preserved in Glycerine

The procedure to preserve leaves with glycerine is very simple, and the resulting shades of handsome brown color and supple leaves are an interesting element to add to your decorations (see page 41).

Method: Mix 1 part glycerine (top grade is not necessary) and 2 parts hot water. Select prime specimens with well-shaped branches free of insect damage or irregular hues. Do any pruning necessary and wash the foliage to remove dirt and any spray residue. Cut the stems of the branches on

the diagonal and stand them in a jar of the glycerine solution deep enough to cover the bottom 3 to 4 inches of the stem. Stems should be less than 12 inches long for best results. Check frequently to maintain this level of solution, adding more as necessary. Keep in a warm place with low light. The solution may be reused many times. The leaves will change color as the solution is absorbed. Allow the stems to remain in the solution until the leaves are all one color. Remove from the solution and wipe dry with a soft cloth. The process will usually take from 2 to 3 weeks. Early summer, after the new growth has matured, is a good time to do this as the leaves will be in active growth and will absorb the glycerine rapidly. If started later, the process will take longer. Good air circulation is important to hasten the process. Once treated, branches may be used as is, or the large leaves may be removed from the branch and used individually. They may be stored and reused another year.

Leaves most successfully treated: magnolia (see page 41), laurel, rhododendron, and other broadleaf evergreens, cedar sprigs including berries, beech, birch, peach, pear, plum, and poplar trees, bayberry, blueberry, privet, and rose bushes. Grasses picked at their prime add a delicate interest and become supple and turn a silky golden color.

Branches, Vines, and Bulbs

In the Williamsburg area (Zones 7 and 8), we force early blooming shrubs such as forsythia, japonica, Carolina jessamine, and some fruit trees for an even earlier touch of spring.

Cut the branches, slit the stems, and stand in a pail of deep warm water overnight. Recut the stems the next day, arrange them in your container, and wait for the blossoms of spring! The Carolina jessamine is a lovely addition to the arrangement in the silver epergne at the Lightfoot House (see page 104).

Narcissi bulbs were started early in the season so the fragrant blooms would be available to use in the cone of pomandered oranges (see page 62).

Collecting Dried Materials

Collect pods, nuts, cones, and other interesting dried materials throughout the year and store them with insect preventative in dust-proof containers. Thus you will eventually have plenty of materials on hand when you wish to embellish a wreath for your door, a garland for your mantel, or perhaps make a dried cone for your table. You could also have several sizes of pine cone wreath bases to which you could attach materials from your supply. It is advisable to bake acorns and other nuts found in the wild at 200° F. for at least 2 hours to destroy any insects living within them.

General Rules of Arranging

(see Conditioning)

Size of materials: Keep the largest pieces near the center of the garland, plaque, or other arrangement and the lightest or smallest materials to the edges. Allow these light materials to extend out to give depth and distinction to your design.

Colors: Have colors well distributed throughout the arrangement, whether it is a cone, a wreath, roping, a Christmas tree, or a floral-filled epergne. Your colors must be balanced to be pleasing. Colors may be concentrated in the center or at the base of a flower arrangement. In an interior arrangement, it is often most effective to use the colors present in the room.

Flowers: Use all stages from bud stage to full bloom. Small buds extending out give depth; the full bloom stage is usually best kept to the center. Vary the texture of the materials you choose.

Style: Try and reflect the style of the room—formal or informal.

Acknowledgments

THE talents of many people have been needed to make this book a reality and I owe them a great debt of thanks:

To Betty Babb, for her wonderful eye for detail, readiness at a moment's notice to provide an arrangement, and creative and unusual decorations that have added immeasurably to this work.

To Dave Doody and Tom Green for the creative photography that comes from talent and long hours.

To Dick and Virginia Stinely for beautifully designed pages, to Helen Mageras for her professional design talents, to Donna Sheppard and Amy Watson for editorial expertise, and to Brenda DePaula and Jan Snow for careful and dependable support.

To Trix Rumford, Carolyn Weekley, and their associates for allowing me to develop decorations and miniatures based on the folk art collection and to Anne Watkins for illustrations and information about the objects.

To Suzanne Brown, Cathy Grosfils, Laura Arnette, and Mary Norment for locating slides and transparencies.

To Libbey Oliver for photographs and to her and the Floral Services staff, including Martha Marquardt, Jan Price, Hunter Curry, and Marley Goodall, and to Clark Taggart, Jackie Smith, Kathryn Marshall Arnold, Jane Davies, and Jody Petersen for many special decorations.

To all who helped with photography in the exhibit buildings and guest facilities, especially Orene Coffman, Susan Winther, and Cheryl Thompson at the Williamsburg Inn, Larry Henry, Bob Gerling, Peggy Lankford, Virginia Miller, and Louise Kelley at Carter's Grove, and, at Bassett Hall, Pat Hurdle, James Parker, who frequently made the house available, and especially Don Thomas.

To Rosemary Brandau, who provided information and recipes for the Palace and the Peyton Randolph House, to Chefs Pierre Monet, Rolf Herion, Marcel Walter, Hans Schadler, and their colleagues for much of the food shown, and to Brenda Pruitt for master recipes.

To Herb Harris at the King's Arms Tavern for his hospitality and helpfulness and to Chef John Foster for his skillfully prepared dishes.

To the Forrest Williamsons and R. A. Babbs, who allowed photography in their delightful homes.

To John Austin, John Davis, Betty Leviner, and Trudy Moyles for the use of treasured objects from the collection and to Calvin Heikkila, Margaret Timbrell, Billy Lofland, Mary Bailey, Patti Pierce, and other staff members at the Craft Houses and Martha Carr at the Prentis Store for the loan of reproductions.

To Susan Winther, who gave me the opportunity to design Christmas trees for the Williamsburg Inn facilities and whose support is very much appreciated.

To Peg Smith for providing several beautiful wreaths and to her, Martha Armstrong, and Jody Petersen for checking copy and providing plant materials, and to the many others who were so generous with their gardens, and to Carol Harrison, my right hand at Christmas.

To Ron Hurst and Emma Lou Powers for reviewing the concept and the manuscript.

To Joe Rountree, who offered encouragement and enthusiasm for the ideas—many of which he had to climb over as they were being made—and to Jeff and Chris, who provided support despite two Christmases that were a bit fragmented on the home front.

And lastly to the residents of the Historic Area, who create wonderful decorations for the enjoyment of our visitors every Christmas.